ROMFORD
THROUGH TIME
Brian Evans

AMBERLEY PUBLISHING

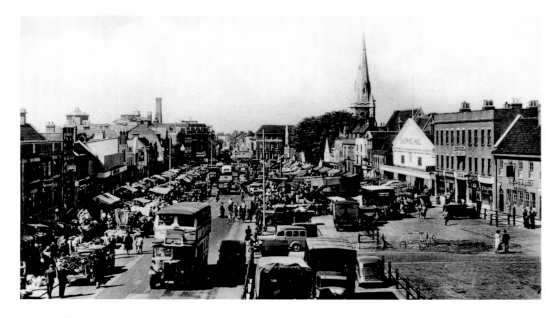

Romford Market in the 1950s
Romford Market has continued down the centuries since the grant by Henry III in 1247. In this photograph Romford has a unity. Its Market Plain is still surrounded by many of the older businesses and inns, but with the advent of the Romford shopping hall sharing the north side with the Pig in the Pound pub on the far right, St Edward's church and the brewery chimneys and towers on the left horizon.

Remembering Bessie Collett.

First published 2012

Amberley Publishing
The Hill, Stroud
Gloucestershire, GL5 4EP

www.amberley-books.com

Copyright © Brian Evans, 2012

The right of Brian Evans to be identified as the Author of this work has been asserted in accordance with the Copyrights, Designs and Patents Act 1988.

ISBN 978 1 4456 0523 4

British Library Cataloguing in Publication Data. A catalogue record for this book is available from the British Library.

Typeset in 9.5pt on 12pt Celeste.
Typesetting by Amberley Publishing.
Printed in the UK.

Introduction

The true heart of Romford is its great market, over 760 years old. For most of this time it has attracted custom from many miles around. In the Middle Ages it had a licence to service the Royal Court and the great establishments of the mighty in London, providing food from the rich acres of Essex farms. The cattle are no longer a feature of the market since the mid-1950s, but the contemporary traders sell all kinds of goods to the local populace and visitors, rather than dealing with the farming community. The great Essex Road that ran through the market now takes a diversion around its edge. Up to the 1960s when the road still ran through the middle there were many chaotic scenes as pedestrians and traffic competed for space. The Romans marched and rode along the highway from London to Colchester here and named their strategic location in the road books as Durolitum. For a time after their departure this main road was largely deserted for fear it might be the route along which North Sea raiders would come. A network of byways, particularly south of the town, centred on east to west routes along the line of the present Hornchurch Road, Becontree Heath and Green Lane from Ilford. The medieval town was at the appropriately named Oldchurch and the centre of things only gradually moved northward to the reborn Essex Road when trade revived, making it the place to sell all kinds of goods, including leather items from Hornchurch.

The Church of St Edward the Confessor followed the trend – being granted a small wood north of the highway by Henry IV in 1406. This church lasted for over 400 years, being pulled down in 1847 and rebuilt by 1850, based on a historic Middle Pointed style of the fourteenth century. It contains intriguing monuments to some great families in the town's history, for instance those of the Hervey and Cooke families. Though surrounded by great swathes of countryside with only farms and small dwellings, Romford became very influential through its central position between London and Essex and the great drawing power of its Wednesday market. Through the centuries the other market days, such as Mondays and Tuesdays at one point, existed for trading other than cattle. A unique relic of prosperous times is the fifteenth-century Church House, built as a speculative venture, but soon to become the location of the priest who looked after the chantry at the church in memory of Avery Cornburgh, a typical Romford grandee who had been an Esquire of the Body to Edward IV and to Richard III, as well as Treasurer to Henry VII. The priest would pray for his soul after his death, to atone no doubt for his riding roughshod over others during his lifetime. There are many clues to the past history of the house – blocked windows of early design and reused timbers were discovered when the house was refurbished in the twentieth century.

Successive waves of prosperity passed over Romford but a great period was the coaching era of the eighteenth and early nineteenth centuries when fast coaches came on to the toll road, some stopping at the many inns and creating a new economy locally. In addition, on market days Essex farmers were at the forefront at this time of new advances in

agriculture and began to seek new services, which brought professionals such as solicitors, doctors, dentists and accountants to the town from London; at first perhaps renting temporary accommodation around the market area for Wednesday sessions, but later, when their various methods of extraction became even more in demand, actually moving out to Romford in more permanent premises.

The Golden Lion, situated at the crossroads, may have been the very earliest business to set up on the reborn highway in the Middle Ages, serving the frequent travellers passing by, and may have started out as a church hostelry. The increase in traffic led to the possibility of its demolition in the mid-twentieth century when it was proposed to widen the old High Street as a remedy. Luckily this historic building remains – so much historic architecture has been destroyed unnecessarily – and today it continues to serve customers as it did in the 1930s, another flourishing time for the town, when South Street nearby was dubbed 'the Golden Mile', one of the most expensive shopping locations per foot area around London, and a magnet to visitors.

Modern Romford has stretched its shopping locations in several directions with three large retail centres in the Mall, the Mercury and the Brewery – an amazing expansion to match the demands of modern times. In this book we concentrate on the main streets and some interesting buildings, even following the old road out of town to the former hamlet of Hare Street, number one candidate for the site of Roman Durolitum and nearby the unique Romford Garden Suburb.

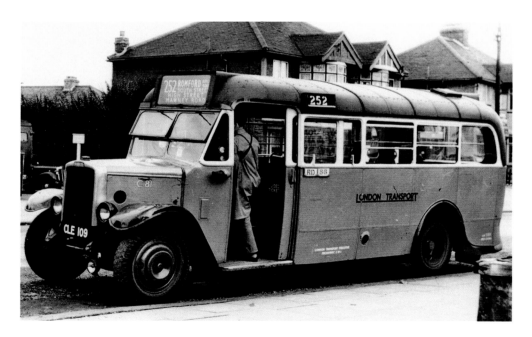

Local Bus
In September 1948 this single-decker 252 route (destination Birch Road) picks up a passenger on its route, which took it via South Street, High Street and Mawney Road.

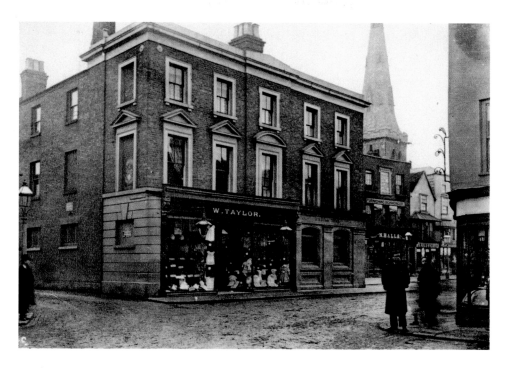

Market Corner

The corner of South Street and Market Place, once known as 'Lazy Corner' when it was a general meeting place, has seen alteration since this scene. A narrower entrance to the Market Place was created by the existence of the Court House on the far side, and these shop premises made South Street longer at this point. In the early twentieth century, South Street was widened on this Eastern side and the obstruction of this shop and the Court House behind were demolished by 1933. In modern times there is a clear view to the Lamb Inn and adjoining properties on the north side of the market.

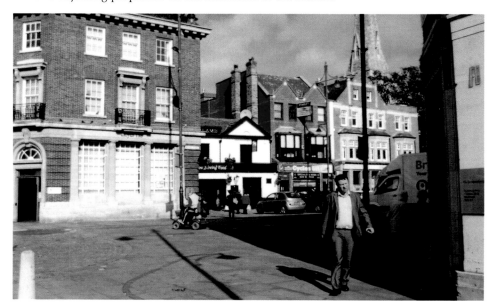

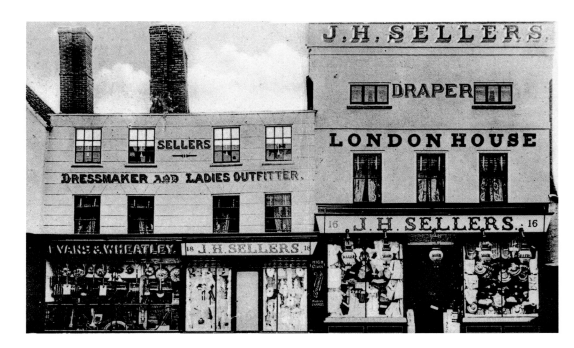

Centuries Old

An Edwardian snapshot of Seller's Drapery establishment at the south-west end of the market. In July 1908 the firm is hastily writing to its wholesalers: 'Bathing Slips on order – when are we to expect them? Wanted urgently.' In 2011 baker's and butcher's premises adjoin the entrance to the Quadrant Arcade – the 1930s dream of Mr Craig – which runs from South Street to the Market Place, providing undercover trading premises for a wide range of businesses. It was necessary to engineer the demolition of the old Court House to complete the project.

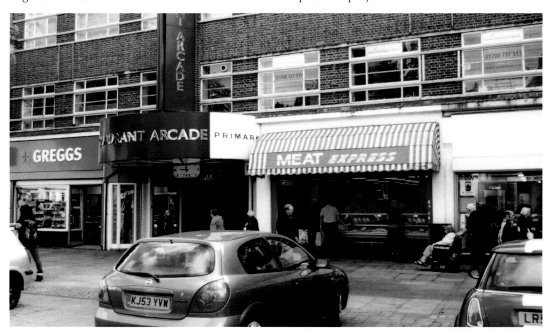

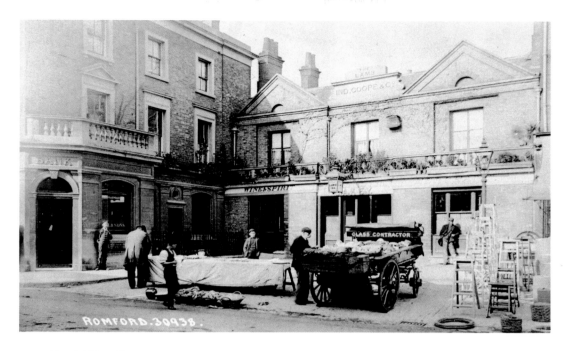

North-West Corner

The Lamb public house sits in its corner at the north-west end of the market in around 1906. The bank premises next door seem to provide commodious living quarters above. The stall preparing for business sold crockery and glassware. In recent years a continental market has been held at certain times, providing a lively scene. Lloyds have taken over the bank premises, rebuilt in the 1930s in neo-Georgian style.

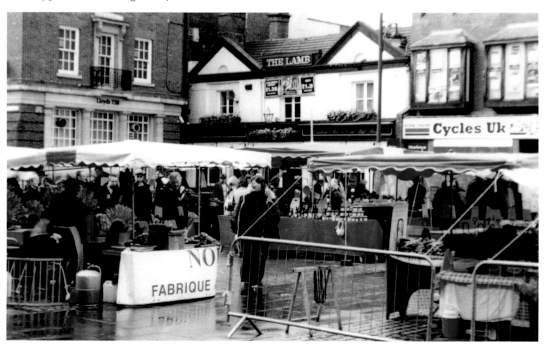

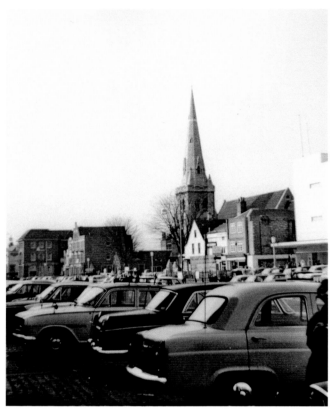

1960s Scene

In 1967 the view across the Market Place was already obstructed by cars on non-market days. Since then the new shopping centres have provided hundreds of extra parking places in multi-storeys. Today's view shows a market in session with a new road, Market Link, between the stalls and the white building in the middle, which is the main way in and out today for vehicles.

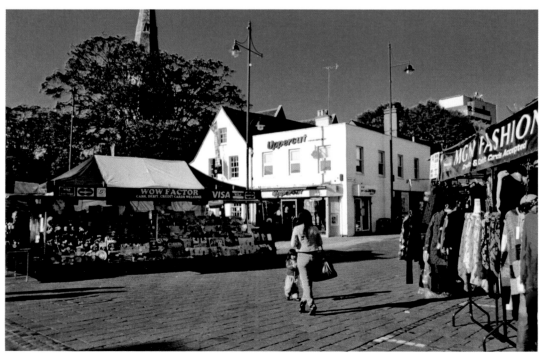

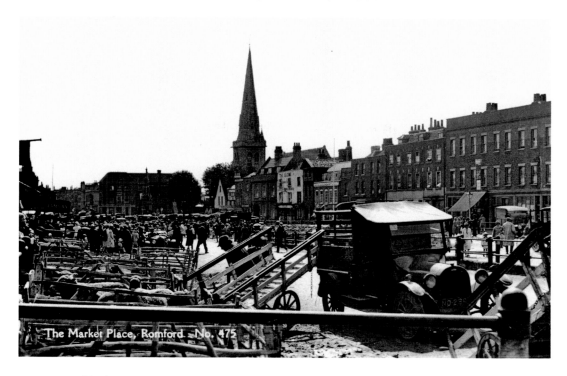

1920s Market

The old Wednesday cattle market in session in the late 1920s. Sheep in their pens can be seen in the left foreground, together with the ramps up to the motor transport that brought them in for auction. In the modern market, allowance has to be made for extensive parking on non-market days to serve the increased volume of trading at the market shops and stores.

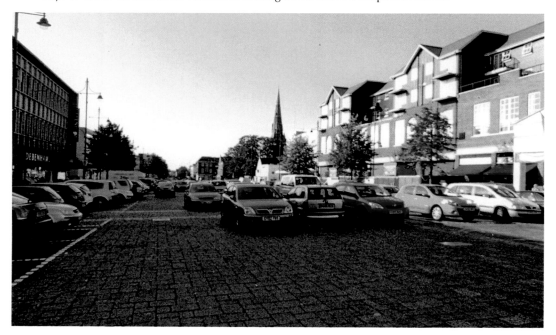

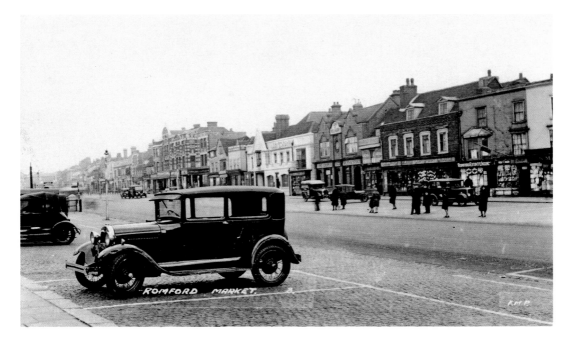

1920s Motors

This 1926 picture shows a relatively uncluttered view across to the south-east side of the market. Some solid motor cars and other smaller vehicles belong to the owners of businesses around the market and the providers of local professional services such as the solicitors and accountants. There are many more smaller shops such as the Romford Estate Agent's, bakers, cafés that compete with the inns seen – the Duke of Wellington and the Swan – and the larger premises of Stone's department store (forerunner of Debenhams). Today Debenhams occupies quite a lot of the same space, with the Bull Inn and newer buildings beyond.

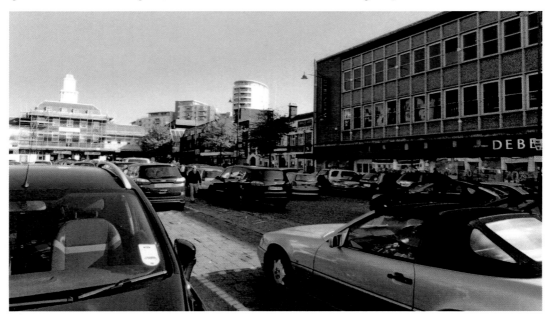

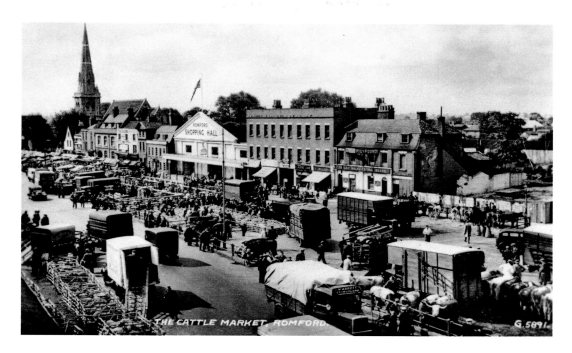

Cattle Market

Sheep contained within hurdles and cattle hitched to the iron railings provided are prominent in this market day scene looking north-west in 1935. The Romford shopping hall (large white building) dated from the mid-1930s, the Laurie Café was situated in the Victorian buildings to the right of it, and the older version of the Pig in the Pound pub was situated to the right of that just before rebuilding. The view ends in a cleared space, where an ancient court and alleys have been demolished. The north side is now dominated by a vast complex of the new shopping hall, flats and shops, which was recently completed.

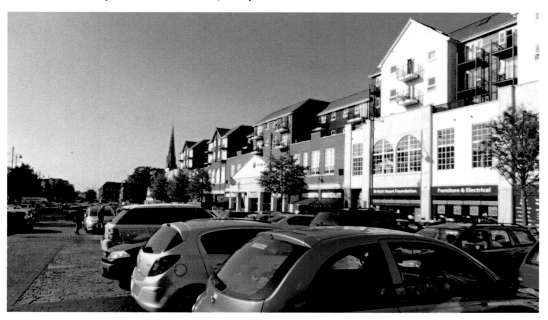

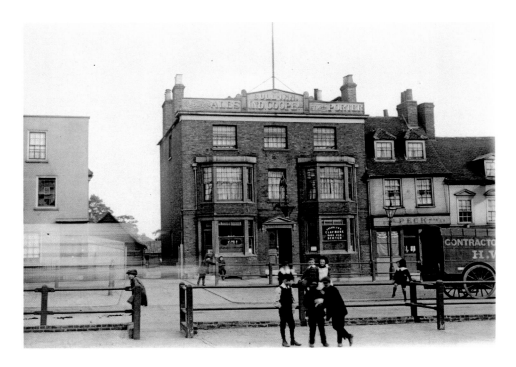

The Bull

This public house and its inn yard behind in a previous identity around 1904. High-spirited boys and girls stand between the railings at pavement and road edge, or clamber on them, fascinated by the old-style photographer. Pecks the bookmaker is the next business along on the right – plenty of trade for him in 1904. The Bull today, with an added first storey above the yard entrance, remains one of a dwindling number of market hostelries, compared to those that once encircled the market.

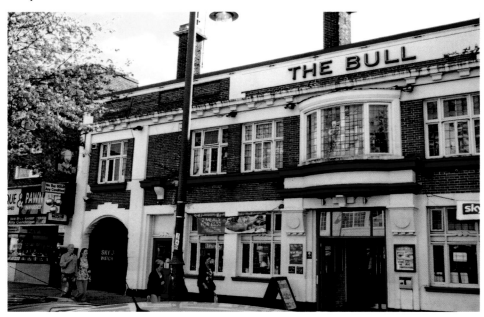

Victorian Buildings

In 1967 the Laurie Café is still situated in this block on the north side of the market. The fascia sign is sponsored by cigarette advertising. The block was demolished and the shopping hall extended over the site, requiring the café to be moved inside. In the twenty-first century, a massive redevelopment has brought these shop fronts into being with housing above in addition to a new shopping hall on the site.

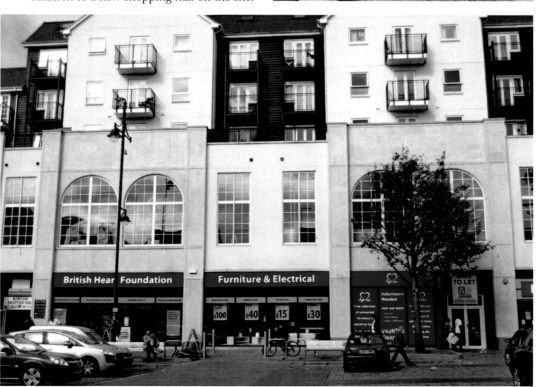

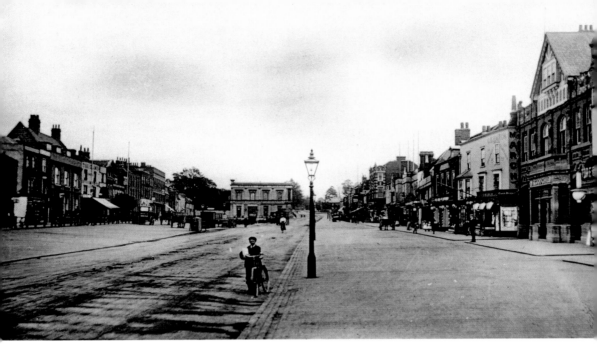

Market Panorama

In the early twentieth century, an eastward view along the Market Place frames the old Laurie Hall in the centre distance to the left of the lamp post. Romford Town Mission occupies the top floor. The nineteenth-century building was soon to house the Laurie Cinema in 1913, showing the new sensational silent films. MacCarthy's chemist shop is on the far right and next to it on the left is the King's Head Inn. The modern view of the building at the top of the market shows the twenty-first century replacement of the Laurie. Tollgate House contains housing, shops and other facilities but wears an outcrop of scaffolding, which has been in place for some time.

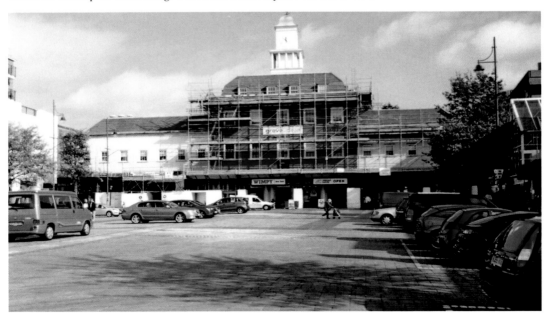

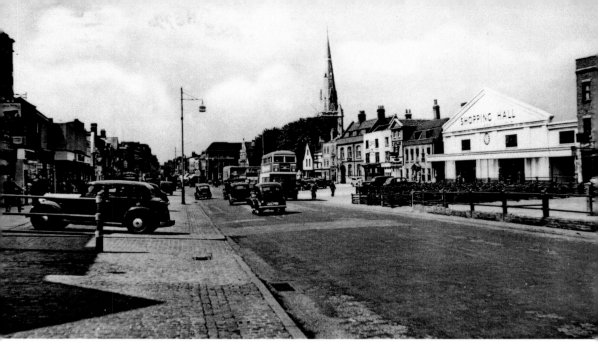

Quiet Market

In the early 1950s the market shows its often peaceful side with the No. 86 bus ploughing through on its way to Brentwood. At this time you could pick up a bus in the market, and the civilised scene incorporates, on the mid-left, one of the innovative 1930s lighting standards – a visible sign of Romford's civic pride. Romford today is a slightly more restless place, complementing its great increase in population and also its shopping, catering and entertainment facilities.

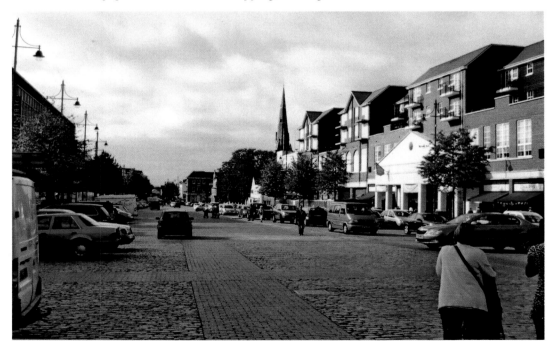

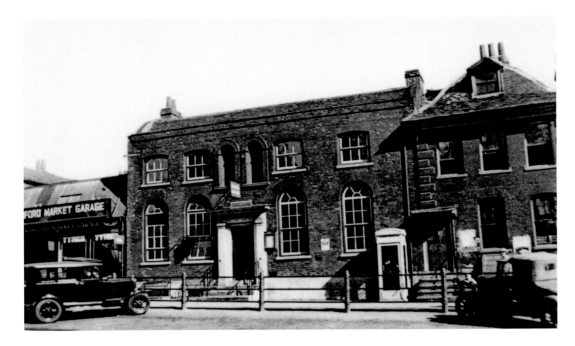

Public Library

The recently opened public library and adjoining buildings on the Pavement, as the continuation of the Market Place into Laurie Square was known. The old Charity School building was converted into a library in the 1930s. This late start occurred after a strong campaign by the Rotary Club of Romford. On the left is Romford Market Garage, run by the Sharpe family. The replacement library on the opposite side of Laurie Square was developed by Essex County just in time for it to act as the new Central Library of the London Borough of Havering in 1965. A recent refurbishment has added a tower with lift and stair access.

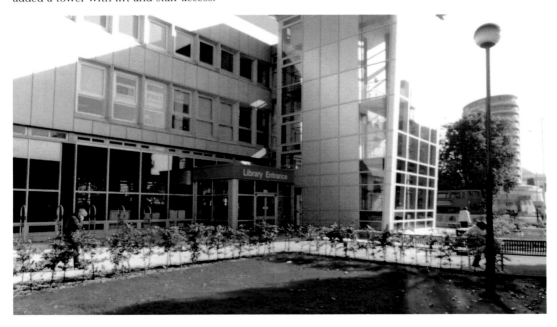

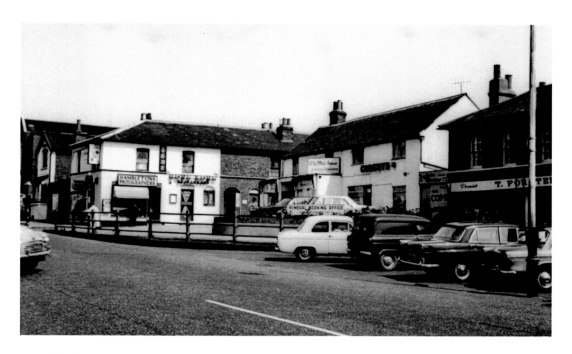

The Pavement

The top end of the market faced Laurie Square, out of sight on the left, and this view shows a 1960s scene. The road narrowed at the point where a line of cottages led away to the right, and Hambleton's photographers has taken over the end premises next to the Hong Kong, an early Chinese restaurant. In the coaching age a toll gate barred the road in this area. Today the cliff-like elevation of Base Apartments towers over the roadway, standing above a supermarket on the ground floor.

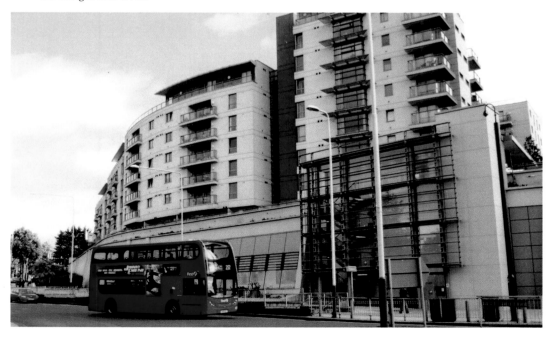

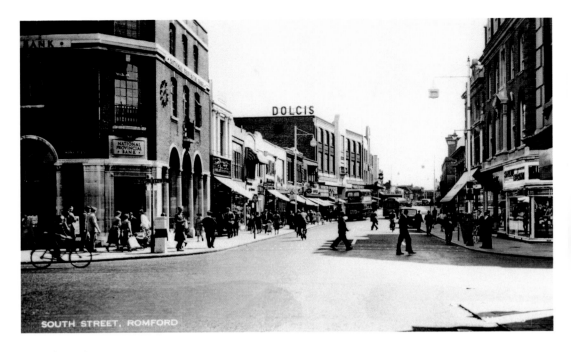

Top of South Street

The left-hand side at the top of South Street had been widened by the mid-1930s. The new National Provincial Bank building on the left was also set back following demolition of buildings in front of it. This made a wider entrance/exit into the Market Place. This junction still accommodated traffic in all directions, but at a slightly quieter moment several pedestrians cross at an apparently leisurely pace towards the Fifty Shilling Tailors on the right. The junction is now mainly pedestrianised like South Street, although the occasional vehicle passes across it.

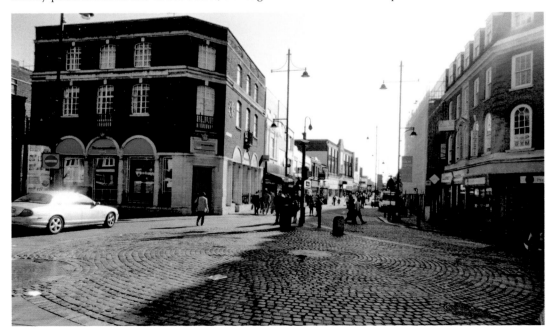

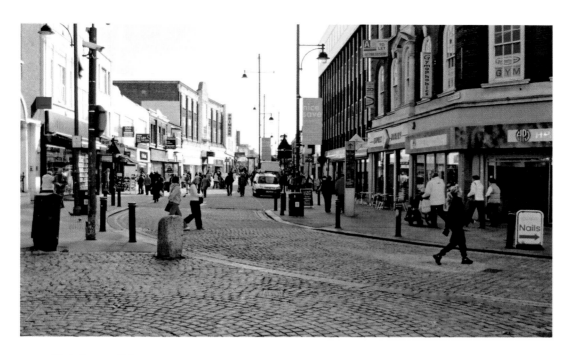

High Street Side

Concentrating more on the right-hand side of the junction, we can see how much wider the street is today. In the early twentieth-century view, the eastern side stretched across to what is the middle of the street today (bollards). Also the left-hand eastern side reaches further into the junction. The shop on the left was an extension from the Court House in the Market Place, which reduced the width of its entrance.

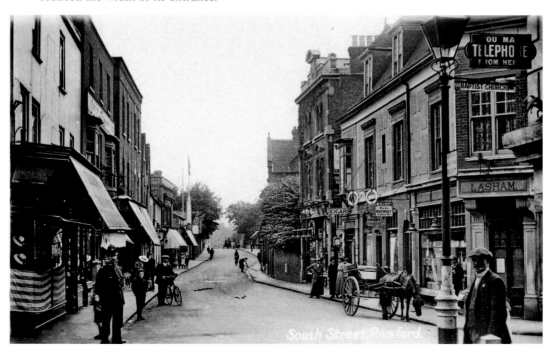

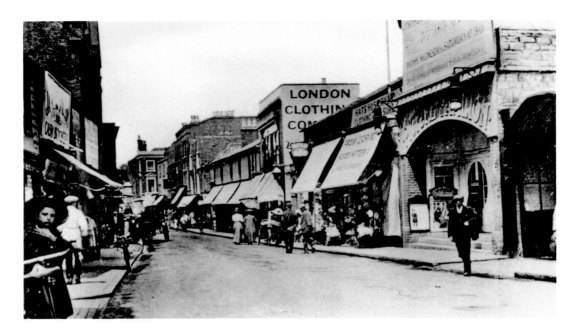

Picture Pavilion

Facing up South Street to the Golden Lion corner just before the First World War, we see the early cinema to the right. On the left were various shops such as Wilson's Discount Book Sellers and Fletcher's the butcher. Beyond was a tall building which had been the post office, recently transferred further down the street to a new building. At the end of the First World War the cinema was renamed the Victory. This part of South Street has been gradually converted into a pedestrian boulevard.

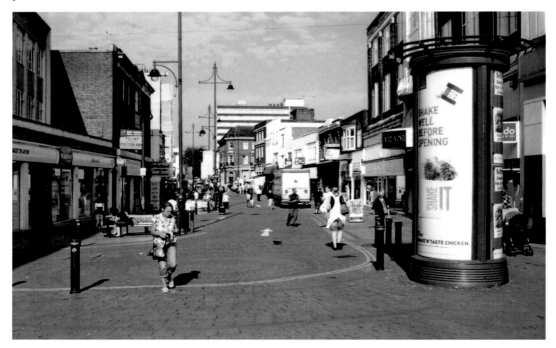

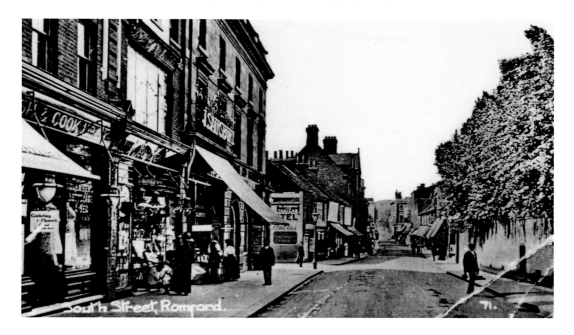

New Shops, South Street

In the early years of the twentieth century, shops were built over what had once been the White Hart Hoppet on the left. Looking up South Street, the shops are Lush and Cook, dry cleaner's, Boots the chemist, J. Sainsbury and the London & Provincial Bank, all by this time national rather than local concerns. On the right (eastern side) at this point the garden wall of Romford Hall still ran alongside the street for some distance – the big house lay behind trees inside the wall. Today this part of South Street still has a bank on the same site with an extension, and the pedestrianised street is wider.

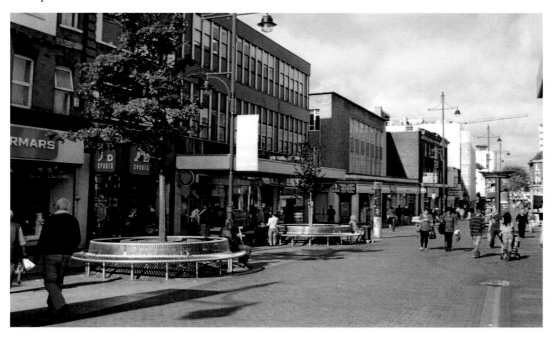

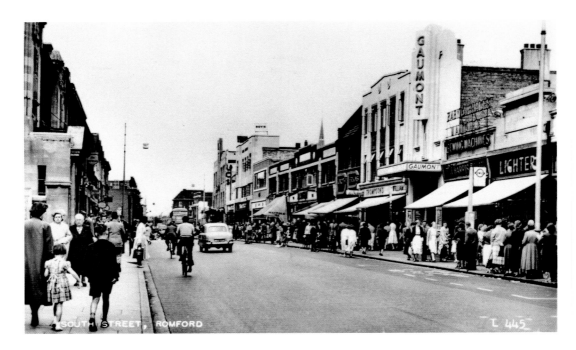

Gaumont Cinema

By the 1950s South Street had been rejoicing in the nickname of the Golden Mile for about three decades. It was one of the most valuable areas per foot measurement around London. Most of the large multiple shopping concerns had a stake in Romford. The Gaumont Cinema had opened as the Plaza on 20 January 1930, and later in the 1930s two extra cinemas followed, further down South Street. The Plaza faced the post office building and replaced the Victory cinema. The cinema entranceway has become a walkway into the Liberty Shopping Mall, but thankfully in this area there is still a good view of the sky, unobstructed by high-rise buildings.

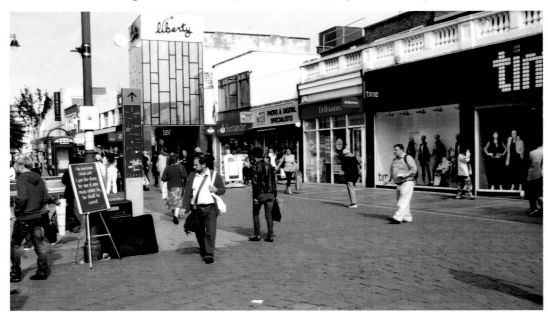

Post Office

The building is seen here soon after it opened – the structure was well built and a sorting office was located at the rear. Life moved at a slower pace, as can be seen by the figures casually walking along the roadway. Doctor Wright's house lies back behind trees and the front garden beyond. A post office no longer, the same building has become a bar and entertainment venue. Part of the old Golden Mile of shops lies above it and traffic has generally been removed from the street.

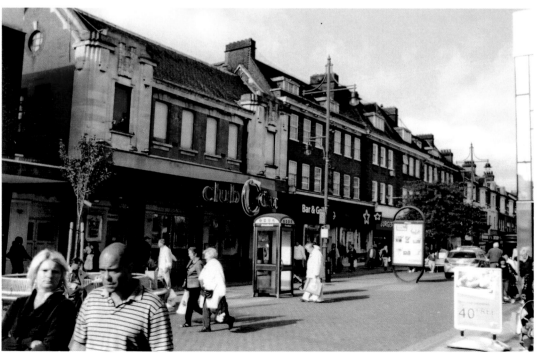

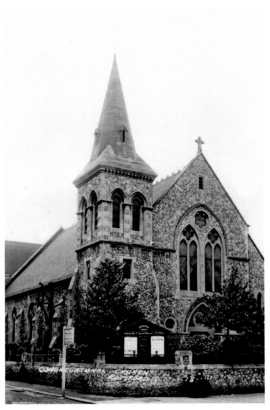

Congregational Church

This stood below the previous group and was originally built in the nineteenth century, rebuilt after a fire soon after, and survived until the early 1960s. The site is now occupied by a bargain shop and a Building Society, while the church has moved, as the United Reformed Church, to Western Road nearby.

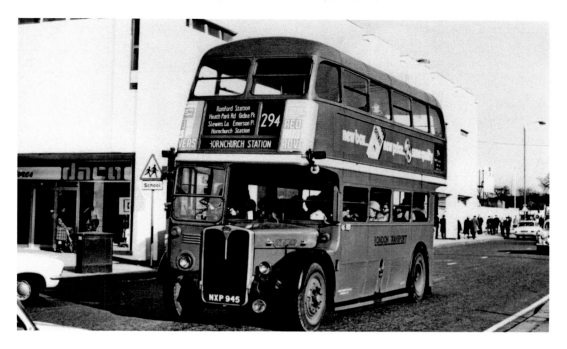

Western Road

In the early days of the shopping mall, the Liberty seen on the left, with its entrance in Western Road, is partly hidden by an older-style R. T. Class bus on route 294. In 2011 the road is more crowded and many of the buses are larger and one-man operated, filling more of the picture. On the left, the refurbished entrance to the now covered Liberty Centre can be seen.

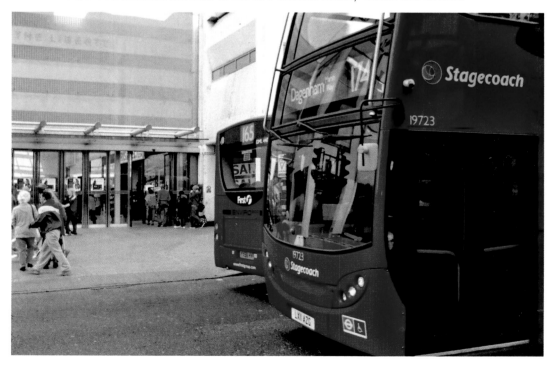

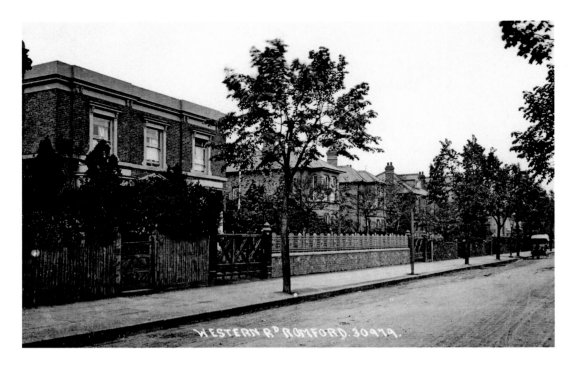

Residential to Commercial

Western Road was, as in this picture, up to the middle of the twentieth century one of the upmarket residential roads for more prosperous citizens. Note the large timber gateways and metal railings protecting the main house seen in around 1914. Now the road is split in two by Mercury Gardens, a radial route. A multi-storey car park is seen to the left, and the roundabout is at the centre with Mercury Mall buildings in the centre background.

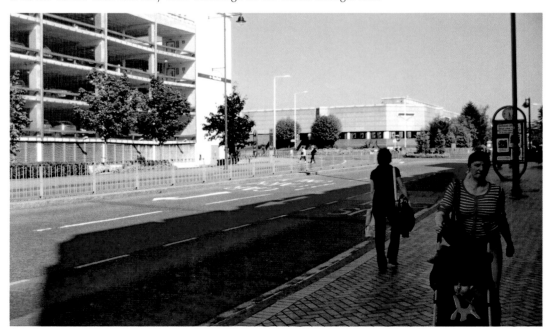

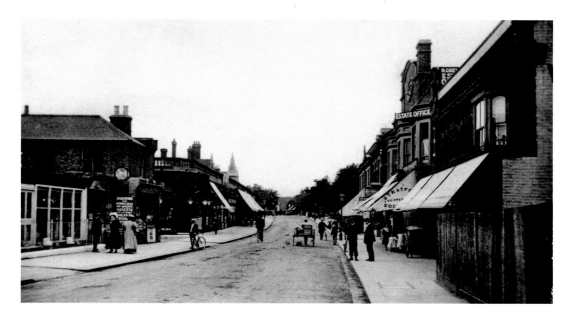

Above the Station

North of the station and Eastern Road around 1912, South Street has seen the front gardens of private houses built over by shop premises. A garden centre is situated on the left-hand side. On the far right is a vacant lot with the Stratford Co-operative Society store above, together with R. Cheke's Estate Office. Behind the trees, right centre and out of sight, is the Romford County Court. In the contemporary photograph, the nightclub on the immediate left is based in the former 1930s-built Havana Cinema, later the Odeon. Above this, four-storey buildings replace single-storey shops. On the right-hand side a wide pavement now contains restaurants and bars, outside which patrons can sit in the summer months.

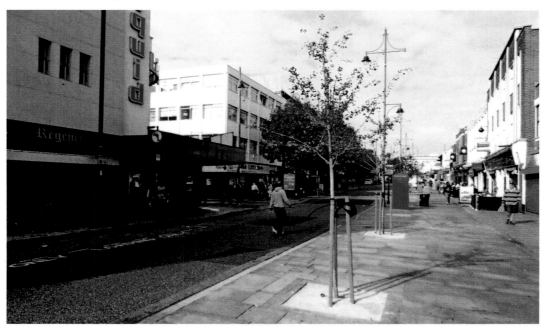

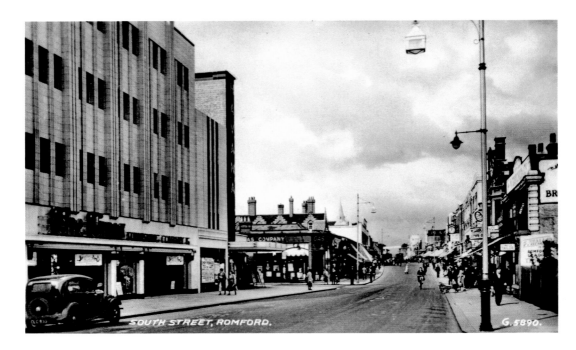

By the Station

In the 1930s, as through most of the twentieth century, the cinema buildings on the left were fronted by the Times Furnishing store. The next corner above housed the Gas Company's shop, which later transferred to the vacant lot on the far right-hand side (corner of Eastern Road) in 1937 as a modern demonstration and consumer showroom, now a bar. An oriental restaurant replaces the Times.

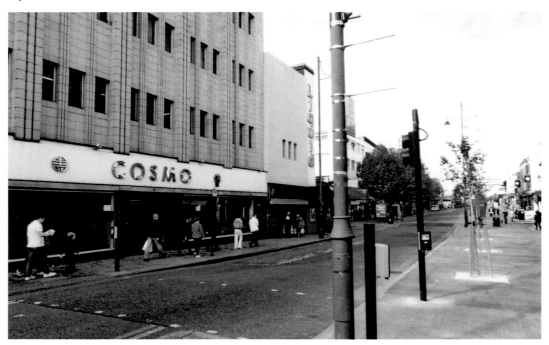

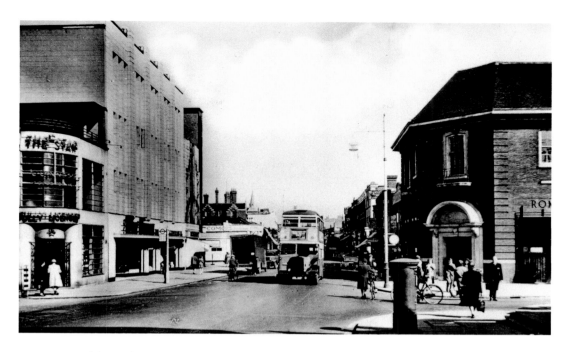

Star Pub/Gas Showrooms

This late 1940s view from the station has the sophisticated Star bar – very popular in wartime with American troops – on the far left, while a 247 bus arrives down South Street, next to the Romford Gas Company's showrooms on the right. In spite of shortages, none of the pedestrians or cyclists seems hurried. Today in a quiet moment at the spot the same buildings remain, but a fire escape has been added above the former Star, which has been incorporated into the restaurant. This area is one-way, and buses now only travel up South Street, or emerge from Eastern Road on the right to join a two-way system under the railway bridge.

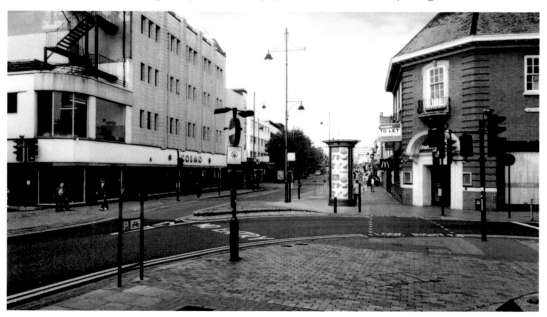

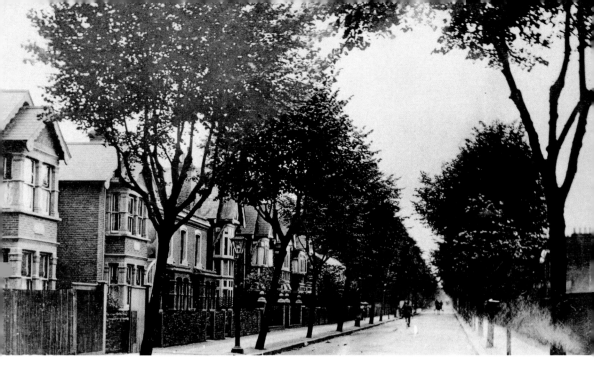

Eastern Road

Currently a taxi rank is located at the end of Eastern Road, convenient for the station users. The older view of around 1910 shows another smart, prosperous road inhabited by the middle classes. The station end today is lined with business and professional premises.

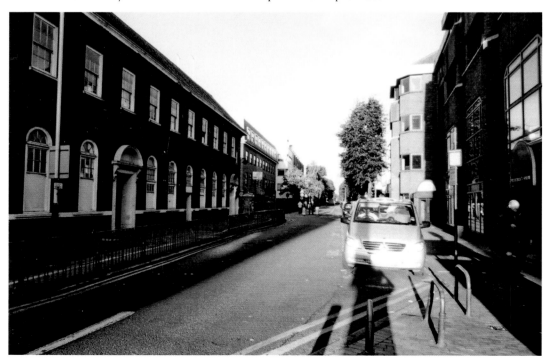

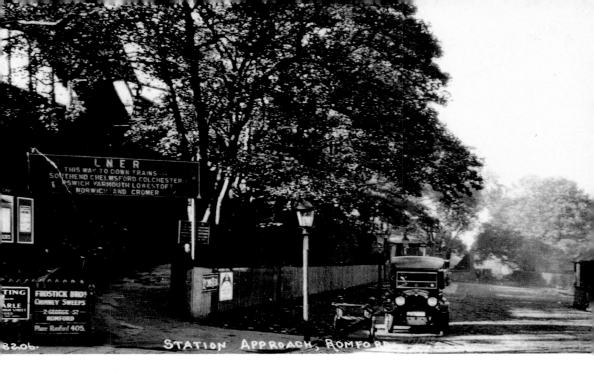

Station Bank

When the railway came to Romford, a huge earthwork – the railway bank containing millions of tons of earth – was thrown up by navvies, on top of which lay the track, along which the snorting monsters of steam engines made their way to London. By the time this picture was taken in the 1920s, trees and greenery made the scene quite rural, cloaking the station in a bit of mystery. The main access was via a slope seen on the left-hand side. A taxi awaits customers by the fence at the bottom. In 1930 the old station was completely refurbished and built out over the space where the taxis stood. Access was now under the bridge.

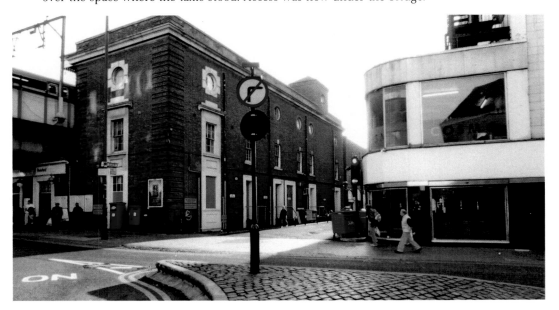

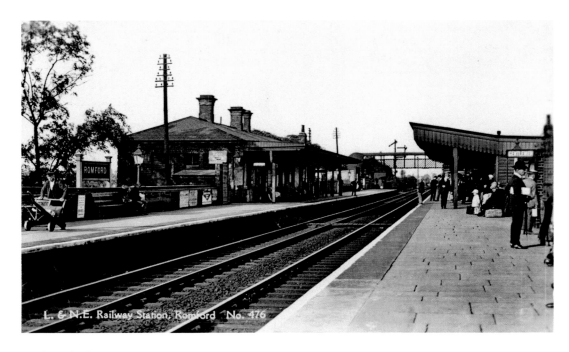

Station Platform

City commuters wait on the Up platform for the arrival of a train in the 1920s. A porter wheels luggage on a barrow to the left of the Down platform. In the distance is the over-bridge between the platforms with the signal posts behind. In the modern view we are facing towards the centre platforms and the two new lines added in the massive rebuilding of 1930. Access to the platforms is now via slopes and stairs tunnelled inside the bank.

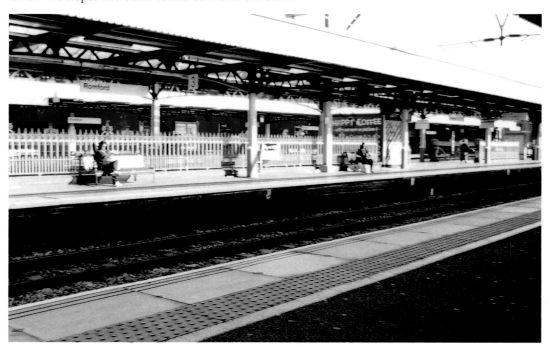

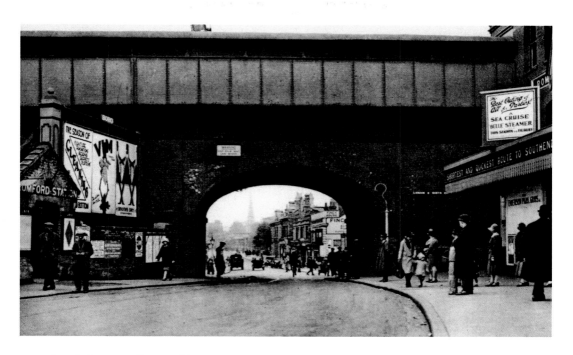

South Street Railway Bridge

The old brick bridge had limited capacity under the railway arch and it is recorded that on one occasion three vehicles jammed together underneath. A view in the 1920s shows the formerly separate London, Tilbury & Southend Railway branch stations entry on the right. The advert above the porch invites passengers to participate in the Best Outing for All – a Sea Cruise on the *Belle* steamer from this station via Tilbury. The new bridge with its attached footbridge for the Upminster line, erected in 1930, today gives more space for vehicles to negotiate. The old station entrance on the right is now a bar.

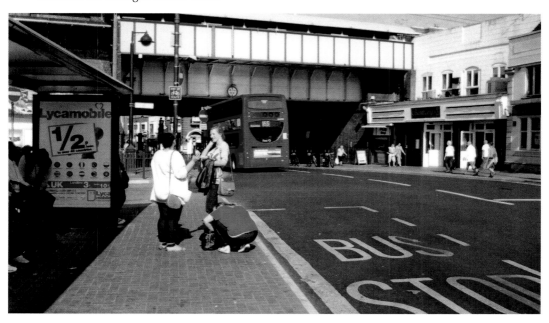

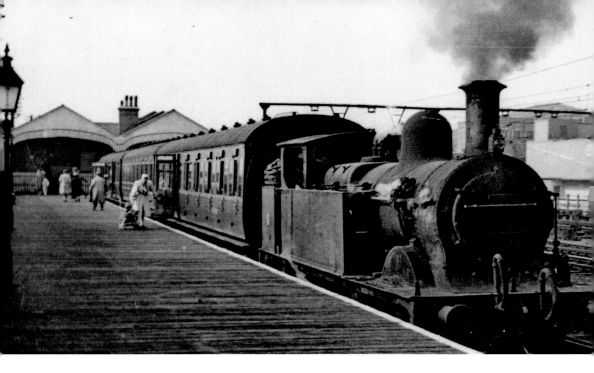

Upminster Platform

On 3 October 1950, a steam-hauled branch train is nearly ready to depart again on its eight-minute journey to Upminster as it stands next to the wooden platform. There is a covered way into the main station. A 1960s view through the gates shows passengers boarding what had, by then, become a diesel service.

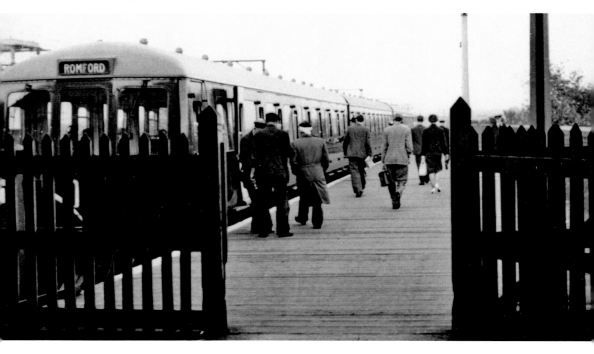

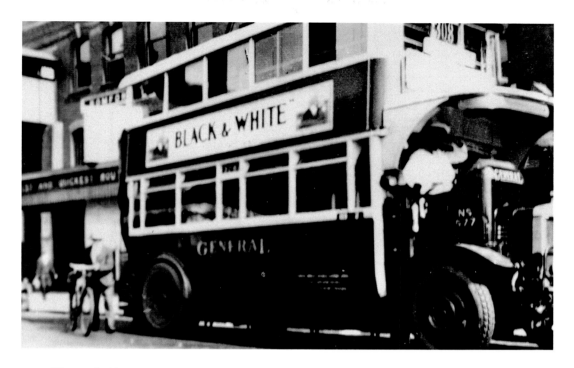

Change in Use

An early twentieth-century N. S. Type bus, No. 577, on route 308 run by the General Omnibus Company in competition with the LTSR station behind. Today the nightclub in the old station building forbids entry to the branch line via the quick route. Passengers first have to enter the main station.

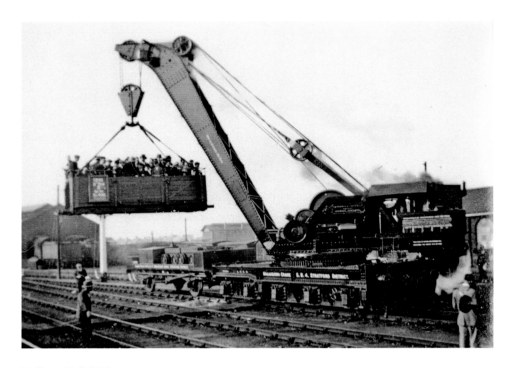

Railway Exhibition

The area next to the station was formerly a goods yard. In June 1936 the London & North Eastern Railway staged a Railway Exhibition in the yard and sidings. Such public relations exercises were held in various towns. One thrilling attraction was a ride in this carriage hoisted by steam crane above the ground. There were no rival attractions like Thorpe Park in those days. A contemporary view shows the front of the station yard converted into a bus station.

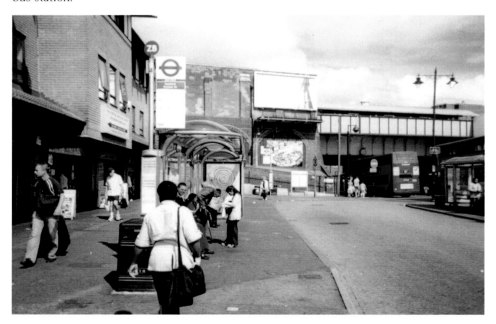

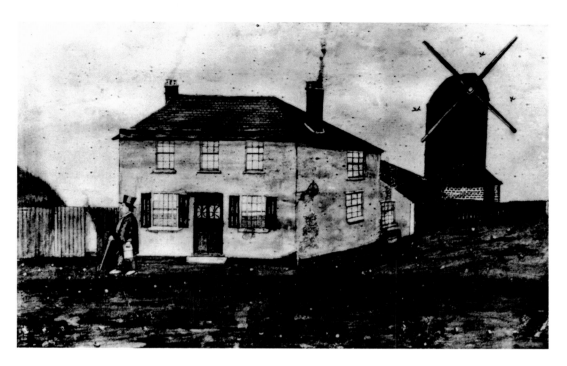

Windmill and Rising Sun

An artist painted this naïve view of the Post Mill, which still stood forlornly for many years after the station bank had cut off its wind power. In 2011 the rebuilt public house has been renamed the Goose but the alleyway next door still leads into a space where the windmill stood.

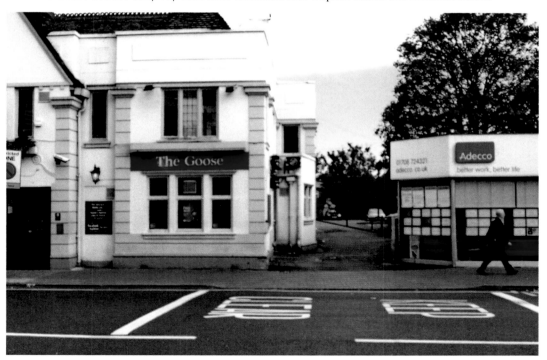

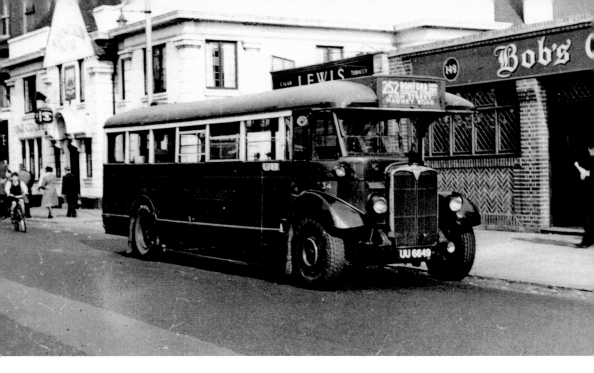

Busy Interchange

Many buses now serve the stops outside the station with buses going south and east. In the 1950s, this Class T 34, route 252, has halted outside Lewis's cigar and tobacco shop and Bob's Café. In today's world these businesses have been replaced by an employment agency and a bookmaker's.

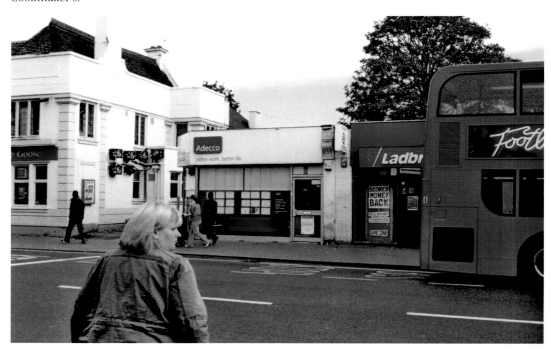

Victoria Road

An Edwardian scene shows that there are still houses at the bottom of Victoria Road on the right-hand side, but shops are gaining the ascendancy beyond. On the left is the bulk of Whitmore's Steam Mill, with a railed-off enclosure for delivery carts in front. Today it is an estate agent's and fast food shops, one appropriately called the Old Mill Café in a block called Old Mill Parade.

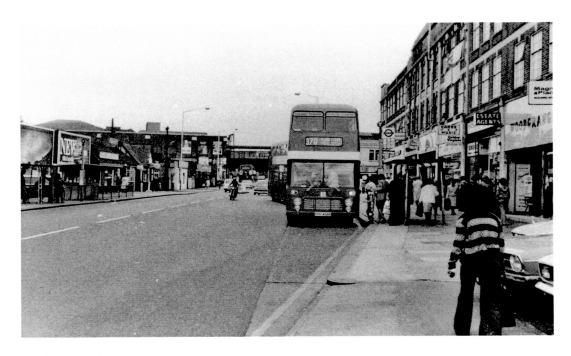

South Street Links

Buses have continued to play an important part in the local scene. Opposite the goods yard, the 370 to Tilbury Ferry is picking up numerous passengers alongside a lively shopping area in the 1970s. A 2011 view shows the left-hand side much rebuilt, and most of the shops on the right have changed hands.

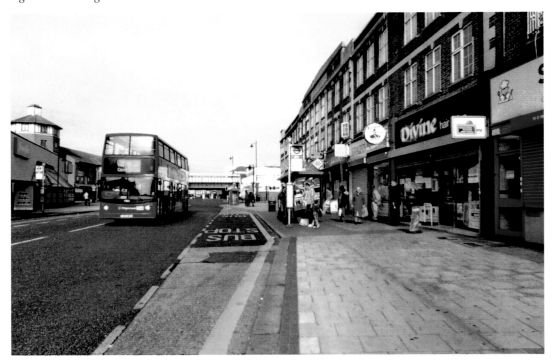

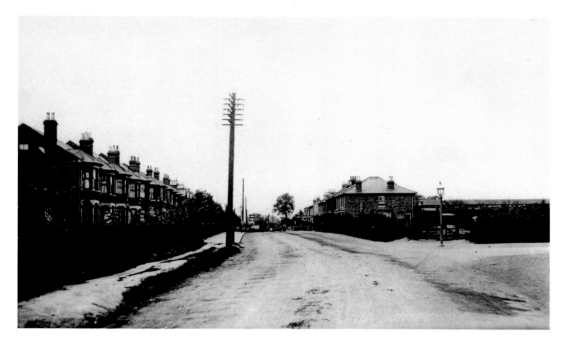

Old Oak Corner

In Edwardian times a winter scene looking up South Street from the corner of Lower Brentwood Road. This part of South Street was then called Hornchurch Road. Most of the Victorian houses in the former photograph are still standing, but we now have a mini-roundabout, road markings and a distant view of what looks like a high-rise city in the centre, compared with the old view.

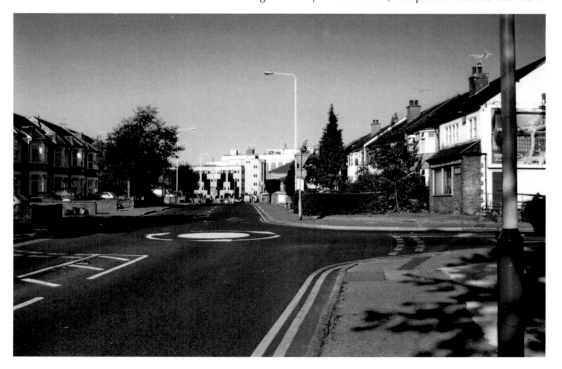

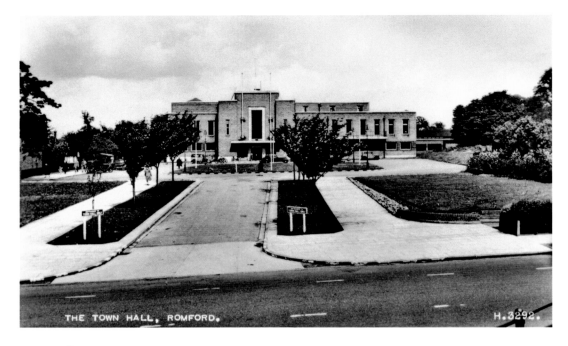

THE TOWN HALL, ROMFORD. H.3292.

Town Hall

An early view of the new town hall, opened in 1937, complementing the new Borough status of Romford. The signs at the entrance on the Main Road sternly proclaim 'Entrance to Town Hall only' and the pavements gleam in their new whiteness. This clever and economical design, not always appreciated by all, was the winner in a competition. Though internally altered, and without the public hall originally intended, it still serves its purpose today.

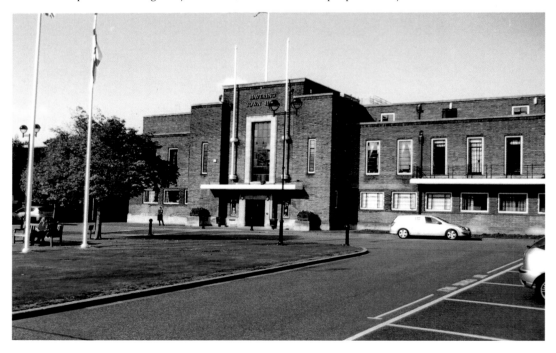

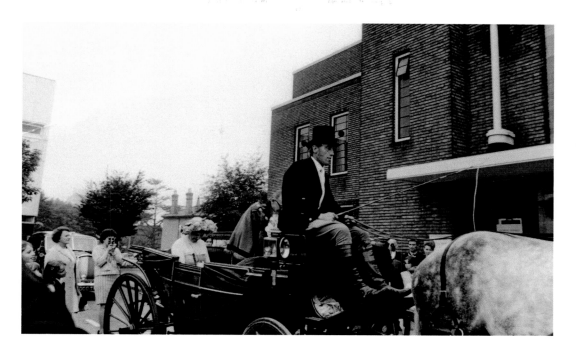

Outside Ceremony

The Mayor, Bill Smith, arrives in a horse carriage on a special occasion, when the road through the market was finally closed in 1969. The celebration of 750 years of its Market Grant in 1997 brought the Lord Mayor of London, Sir Roger Cork, to the town where he is seen with the Mayor of Romford, Del Smith, Leader Louise Sinclair and Air Commodore Brian Batt, Deputy Lieutenant.

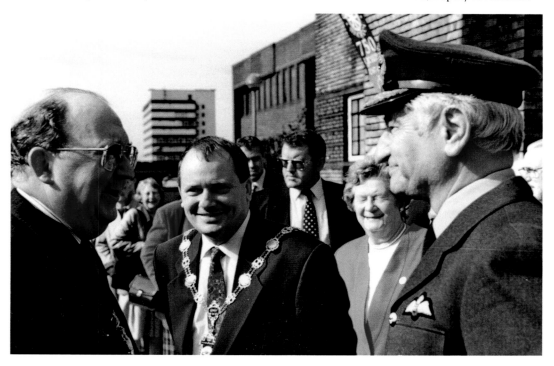

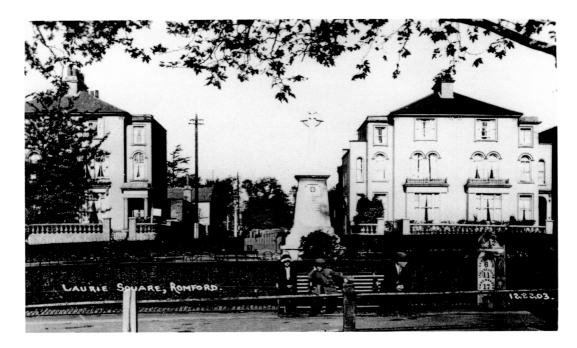

Laurie Square

The charming Laurie Square once provided a quieter view of the Romford scene with its pairs of early Victorian townhouses and the war memorial on its original site. The bulk of Laurie Hall, out of view on the left, shielded the Square from the noise of the Market Place. A final touch is added on the right where the venerable 'twelve mile from London' milestone from the original toll road is retained. A roundabout stands on the spot, some trees remaining from the old square loom over the underpass. The refurbished Central Library is beyond.

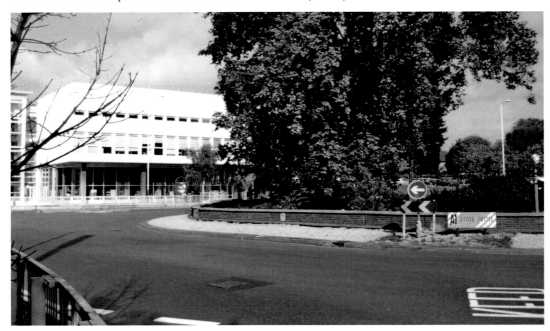

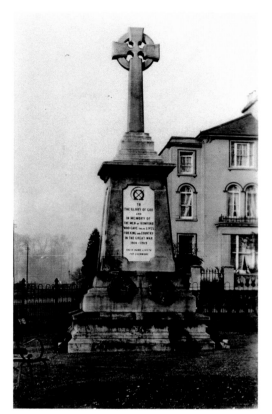

War Memorial

A classic view of the original war memorial site in the 1920s. Much discussion in committees took place before this design was eventually decided upon, sometime after the end of the First World War. Some of the detail of the townhouse behind is glimpsed – one of these was once used to house the children of parents in the workhouse, and their faces could be seen sometimes pressed against the upstairs windows. The war memorial with its wreaths is currently sited in the Coronation Gardens.

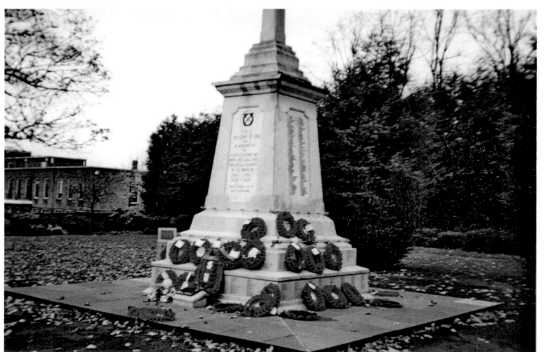

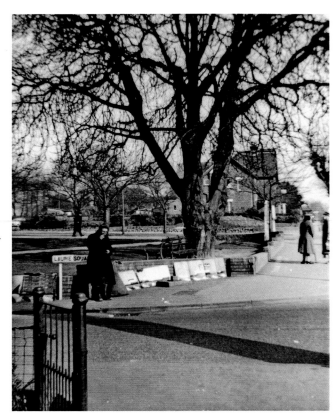

Ship Paintings
A character known as 'Peter the Painter' displayed his artistic side with paintings of ships on cardboard, displayed at the front of Laurie Square on 9 February 1967. He preferred the outdoor life and slept where he could – in the early days tramping his way along the A127 in the evening to sleep under an over-bridge. Today the site of his pitch has been subsumed by the Ludwigshafen Place underpass.

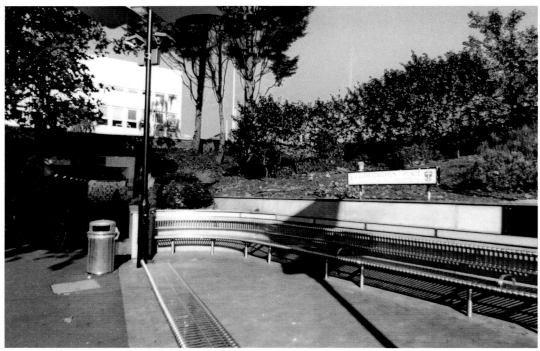

The Lych Gate

This originally stood in front of the small cemetery with the chapel seen in the earlier picture. In 2011 the repaired entrance leads into Coronation Gardens, created in 1953 as part of the celebration centred on the new Queen. Services are held on Remembrance Day around the war memorial, which was removed here in the late 1960s.

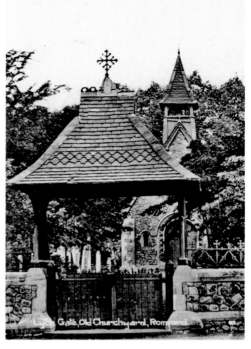

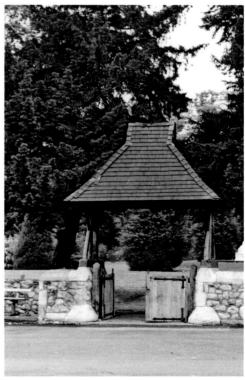

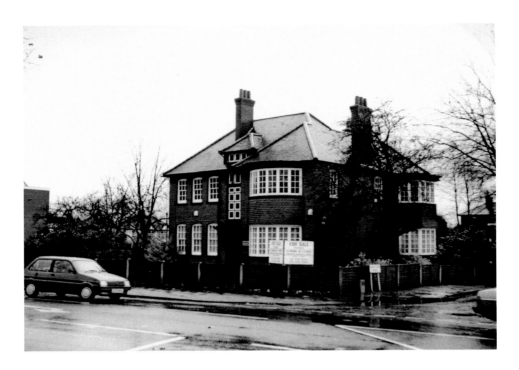

Doctor Upward's House

This house, built for Doctor Upward on Main Road in the early years of the twentieth century, had a side entrance in Junction Road for his surgery. Its beautiful pointing and general charm survived into the late twentieth century, but like many other important buildings it was demolished and redeveloped. Doctor Upward's son became an experimental writer, and a friend to other notable authors of his time. Both Christopher Isherwood and W. H. Auden, as young men, visited him here on a number of occasions. Edward Upward can claim to be a Romfordian of note, although he moved away to other places, and was still writing and publishing over the age of 100. The apartments replacing Edfu, the original house, are named Upward Court in his honour.

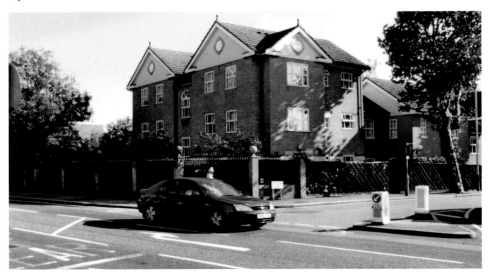

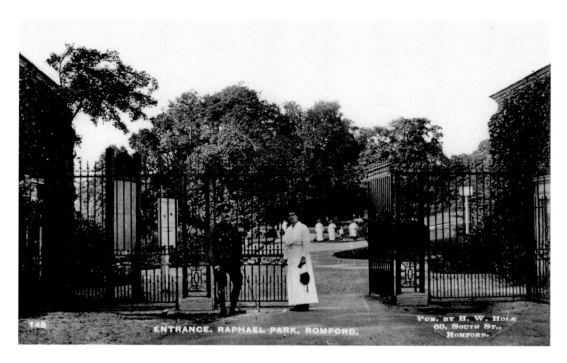

At the Gates

During the First World War, the entrance to Raphael Park was a popular meeting place for soldiers and their female companions. The celebration of 100 years since the park's opening was made colourful by this group in costume.

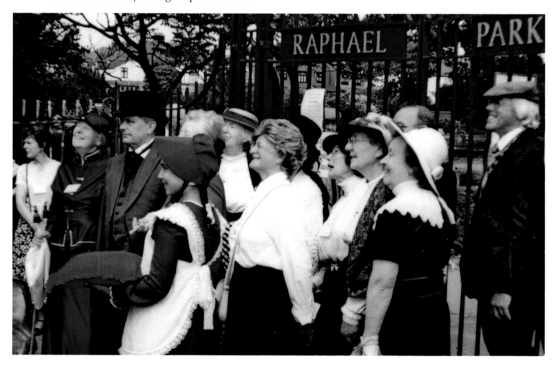

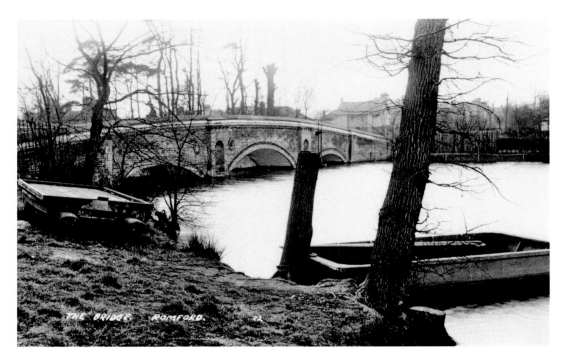

Black's Bridge

Around 1930, a winter view from inside Raphael Park towards the elegant bridge, which the Main Road still crosses. It was described as a 'bridge of three elliptick [sic] arches designed by Mr Wyatt'. The lake, originally known as Black's Canal, like the bridge named after Alexander Black who purchased the Gidea Hall Estate in 1802, was a decorative feature. Trees obscure part of the bridge in this photograph, but add to the attractiveness of the scene.

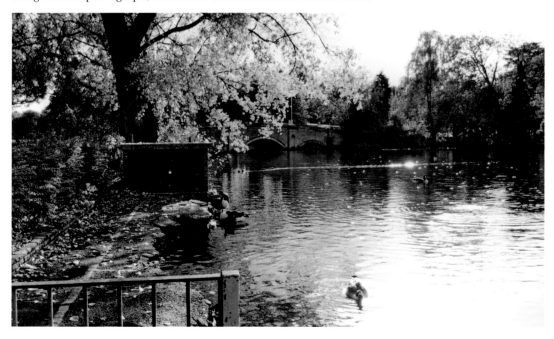

Pretty Walk

The woodland at the rear of Raphael Park was added to the original plan, and contrasts well with the open areas. It has changed only a little over time and leads to an exit to Lake Rise.

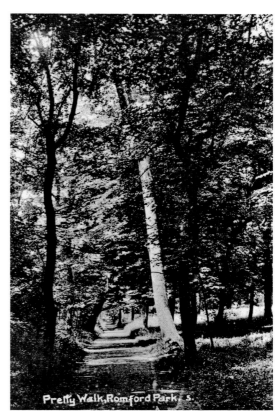

Pretty Walk, Romford Park, 5.

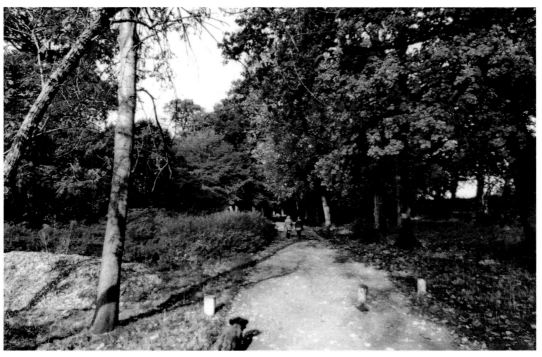

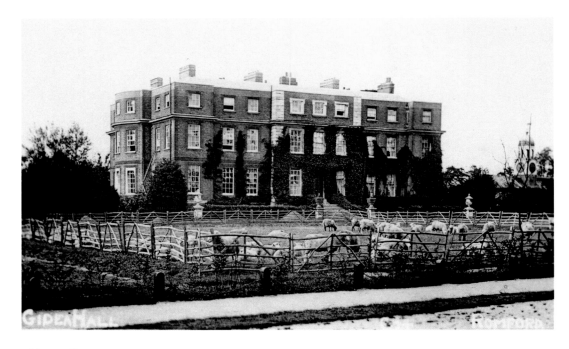

Gidea Hall

In the early twentieth century, the rebuilt eighteenth-century Gidea Hall was a rather plain and truly Georgian building of three storeys. Sheep are seen grazing in the front meadow, which may have been hired out as a fattening ground for these animals, which were to be sold in Romford Market. The meadow became the tennis courts of the Gidea Park Lawn Tennis Club, and is today surrounded by hedges.

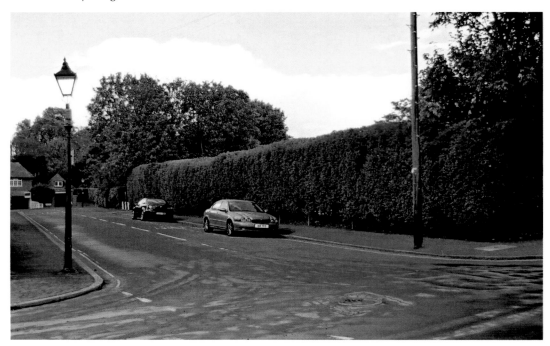

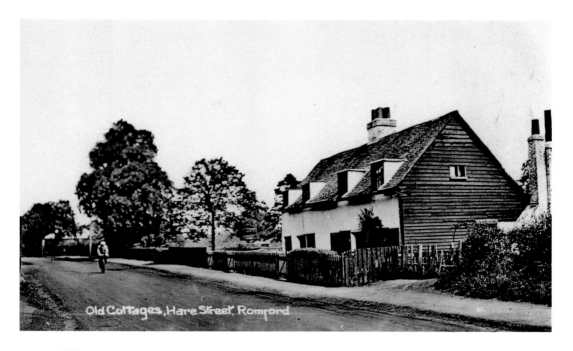

Old Cottages, Hare Street, Romford.

Old Cottages

A few of these still stood among the fields surrounding Main Road in the early twentieth century, with wooden picket fences and examples of topiary in the grounds. Main Road is today built up with more modern houses, some showing influences from the designs found in the Gidea Park Garden Suburb.

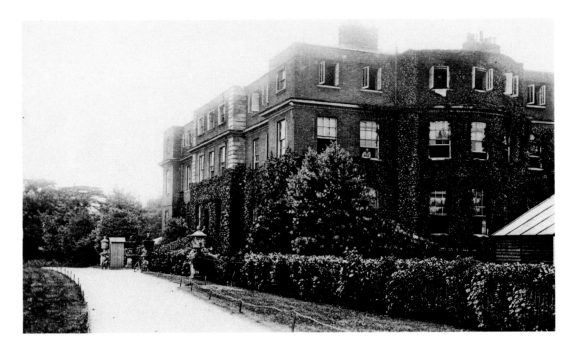

Artists Rifles

Seen when occupied by the Artists Rifles OTC during the First World War, Gidea Hall has acquired a sentry box at the foot of the flight of entrance steps. Many of the windows are open to air, with the rooms fully occupied by the troops. No visible trace remains of the hall, except the pathway that ran along the front.

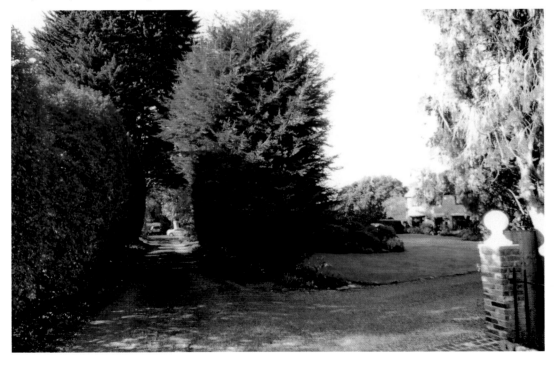

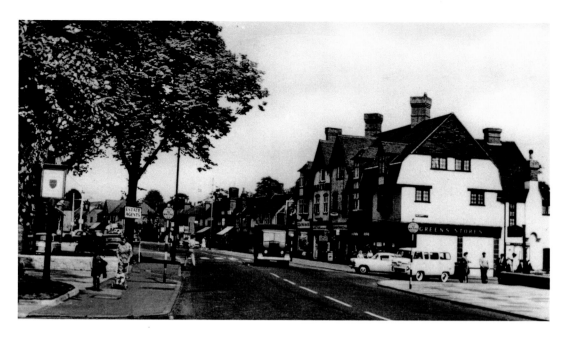

Hare Street

By the mid-twentieth century, the hamlet of Hare Street had grown up into a suburb. This is the scene that greeted travellers coming from Romford in the 1950s. Many of the original features remain, including, right-centre, the block of shops with flats above, which were built after the opening of the Garden Suburb, the main part of which is approached by means of Heath Drive in the left foreground. The original bank behind has become an audio store.

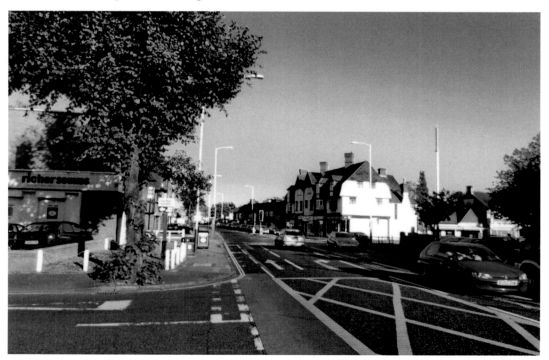

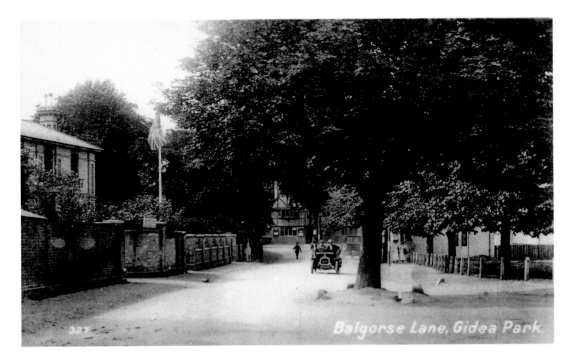

Balgorse Lane, Gidea Park.

Balgores

This house is seen here surrounded by brick walls with a Union Jack flying in around 1916 when it was occupied by the Artists Rifles training corps. The famous poet Wilfred Owen was here. The huge tree in the picture was removed about fifty years later. With unreliable steering, the early motor car pictured would be liable to mishap. The front wall has lost its railings now, and the building is occupied by Gidea Park College, who took it over after the First World War. Traffic has increased steadily over the century in Balgores Lane.

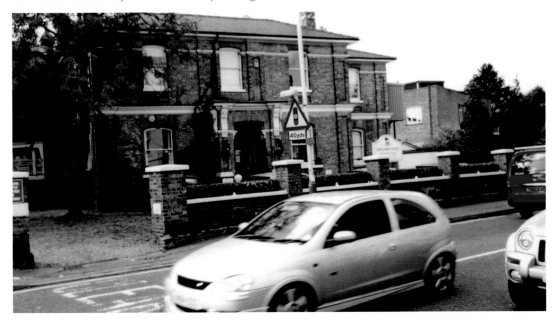

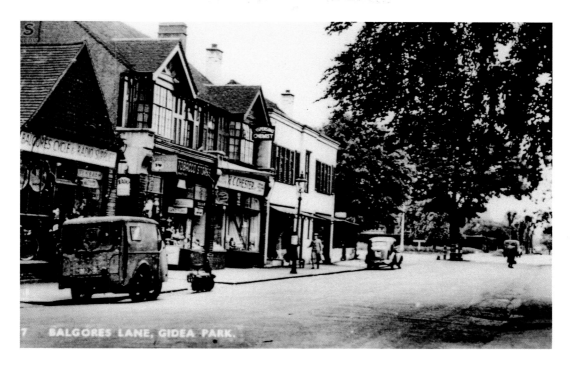

Balgores Lane

In the mid-twentieth century, the shops opposite the school include one selling cycle and radio supplies, tobacco, chemist's supplies and the dress shop, and the tree is still *in situ*. These have been replaced by a salon, a bakery, a sandwich bar and a bank, while the pharmacy remains.

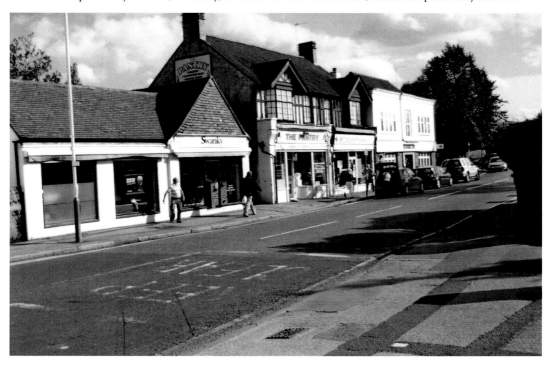

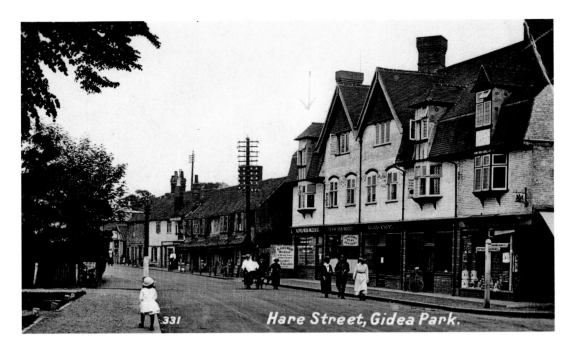

Hare Street, Gidea Park.

The 1912 Shops

This general view of Hare Street again dates from the First World War when the soldiers primarily occupied Hare Hall camp. The shops were occupied by a military tailor's, tearooms and the Khaki Café with Green's Stores on the corner. Today's scene incorporates an estate agent's, butcher's, beauty salon, dry cleaner's and a Chinese takeaway.

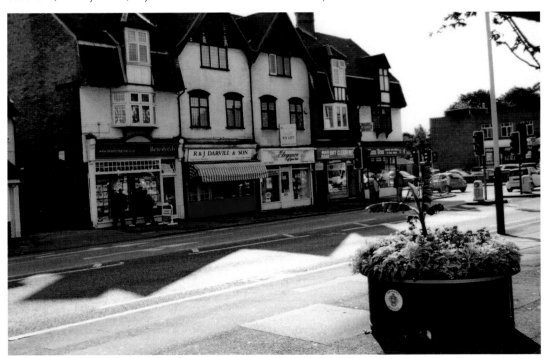

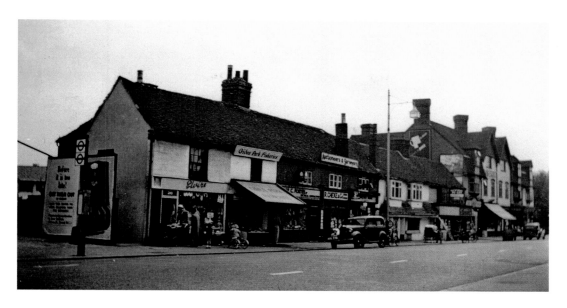

White Hart Cottages

These cottages turned into shops in the mid-twentieth century, and looking along we see the sparser traffic situation, with one car parked along the front facing the wrong way. Shops include Eluire Dressmakers, Gidea Park Fisheries, E. G. Porter Electrical Contractors and Cheke's Auctioneers & Surveyors. The end of the block contains a hoarding advertising Bass Beer. Archer's bar now occupies one of the shops in addition to the old buildings that housed the White Hart pub up to the nineteenth century. The I. C. E. Man (new technology) and Radhuri Indian takeaway and restaurant occupy two of the units in the cottages.

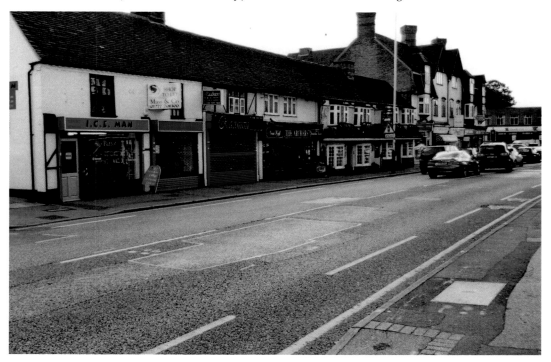

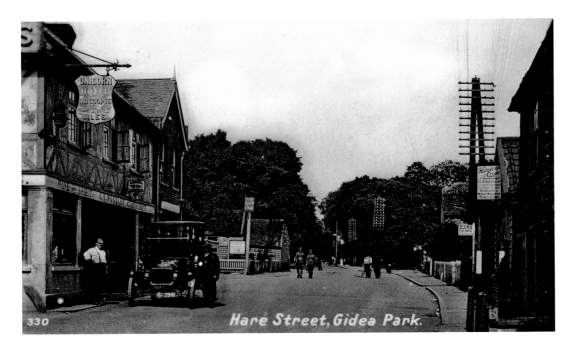

Hare Street, Gidea Park.

The Unicorn in 1916

This interesting photograph shows the Unicorn – quite an old pub name – on its original site nearer the road, and outside a taxi awaits a fare, perhaps from a well-off soldier from the Artists Rifles making maximum use of his limited break from his period of training. Perhaps the cinema in Romford beckoned or a walk in the park with some local young lady. Large trees dominate the background on both sides of the road, along which two soldiers are strolling. The Unicorn, which is now a Harvester restaurant, was rebuilt some way back from its original position, and the Ship Inn beyond is now nearer the widened road.

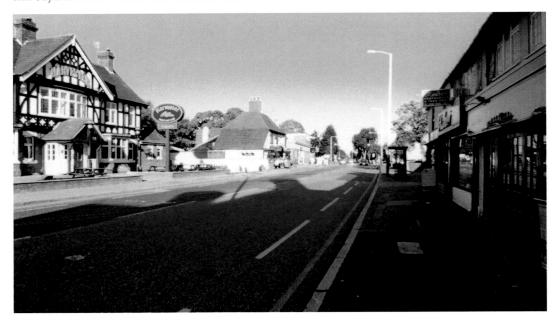

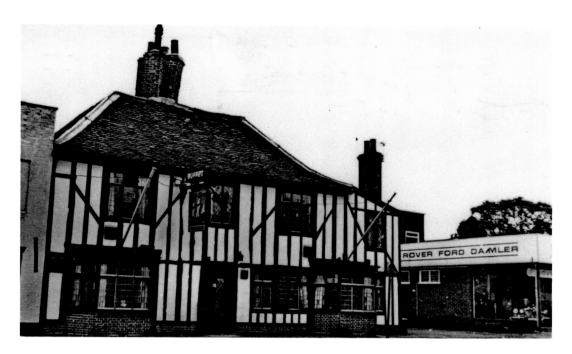

The Ship Inn

In the 1960s the inn was slightly smaller. Part of the small house, a section of which can be seen on the left, was eventually incorporated into the hostelry, as seen in the later photograph. Today the building on the right has become a golf shop, still looking a little out of place in its modernity as it did when it was a Rover, Ford and Daimler dealer in the 1960s.

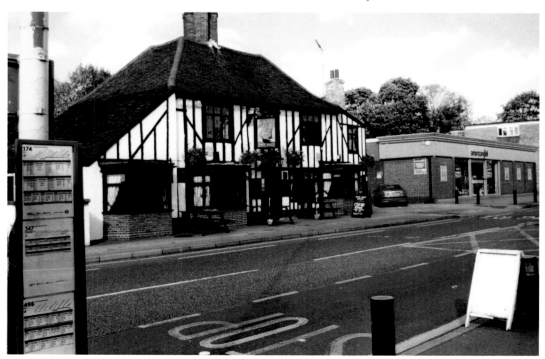

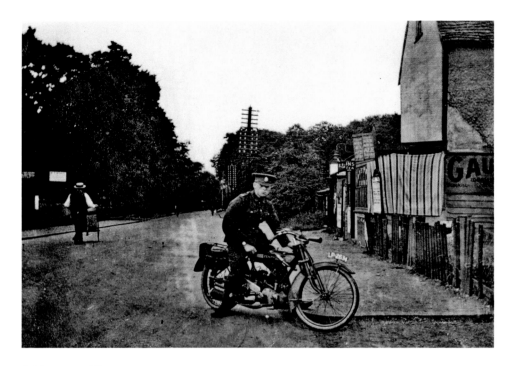

A Ride on a Bike

This unique picture from First World War shows a young soldier astride a motorbike, which may have been lent to him for posing purposes. Did the photograph go back to his family, to reassure them that he was getting on okay in his training with the Artists Rifles? He is pictured outside the nearest refreshment building to the Hare Hall Camp, a rather ramshackle structure. The scene today shows an MOT centre, shops and the houses of Gidea Park, built after the war.

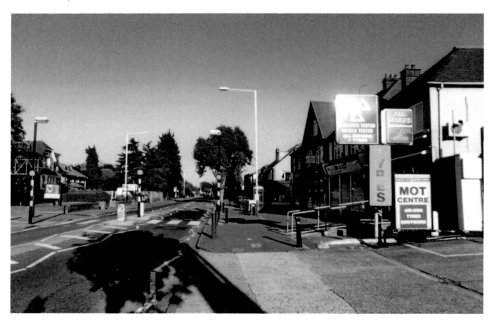

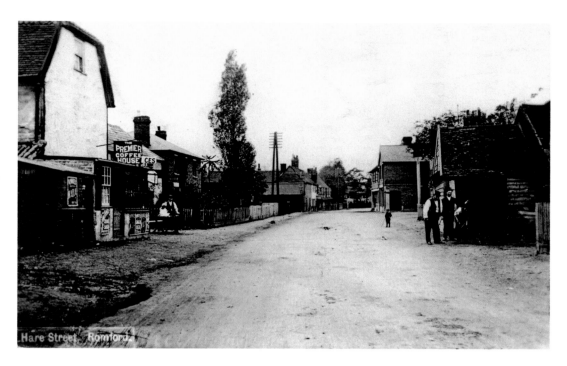

Hare Street

Looking towards Romford we see the Premier Coffee House from the other side. It faces a blacksmith's workshop across the road. The Ship is hidden behind in this view of 1908. Shadows fall across the current scene on a wider road.

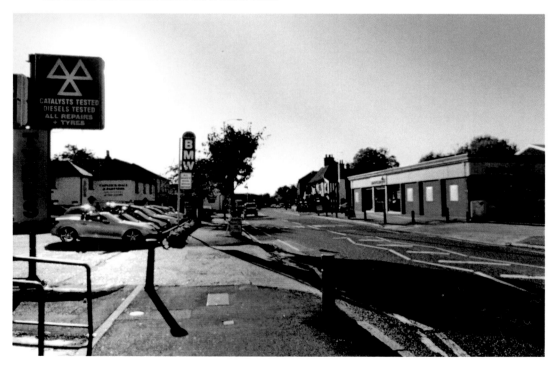

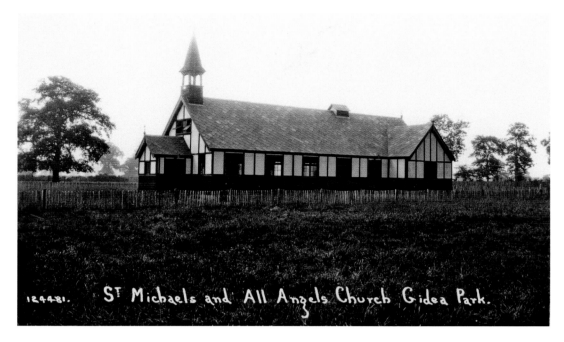

St Michael's Church

Set on a large plot among fields, the first temporary church in the picture has only recently been constructed and photographed for the purposes of this postcard. Later, an unusual permanent building designed and opened in the 1930s gives almost a continental feel to the suburb today.

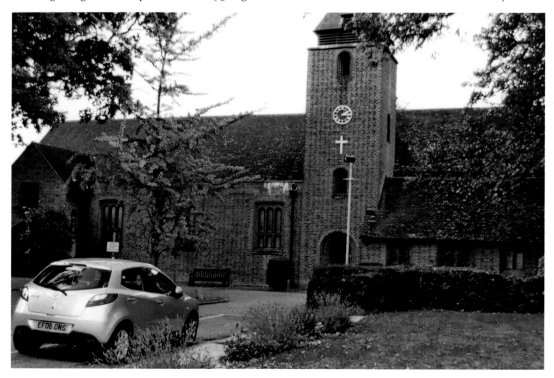

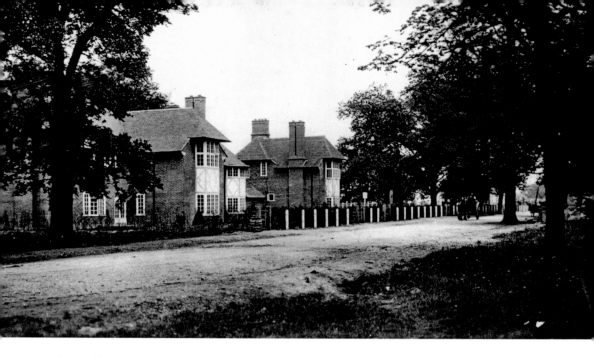

Elm Walk

No pavement has been laid in this early photograph of Elm Walk on the Romford Garden Suburb, taken shortly after the houses were completed. Some of the field trees of the original Gidea Hall Estate remain *in situ*. Newer trees now shroud the frontages of most of the houses.

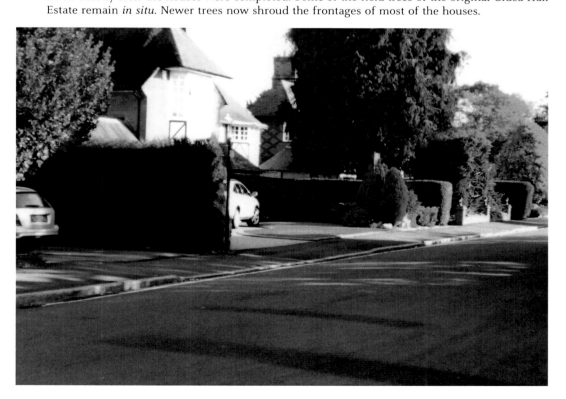

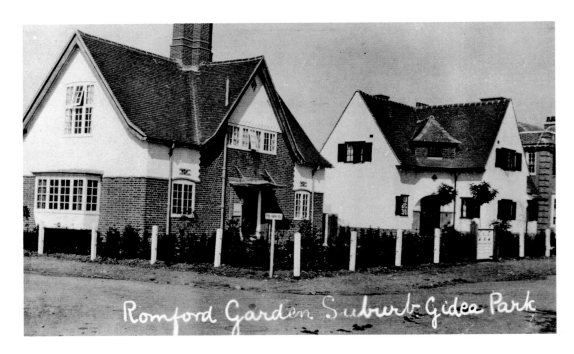

Romford Garden Suburb-Gidea Park

Curtis Green House

On the northern corner of Meadway and Heath Drive, this contemporary photograph of the newly constructed house by the architect Curtis Green displays an unobstructed frontage. A modern view of the Grade II listed house shows how the hedge and trees now partially screen it.

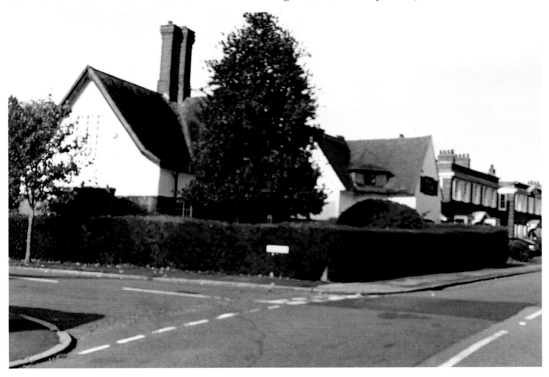

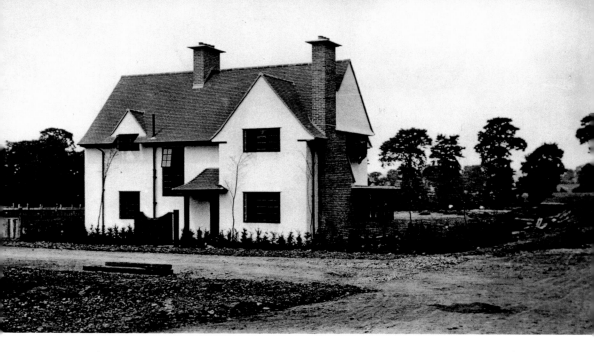

57 Heath Drive

On the corner of Heath Drive and Risebridge Road, the exhibition house designed by G. L. Pepler and E. J. Allen is shown as first built. Still very recognisable today, the house has now settled down in the local environment of this unique area.

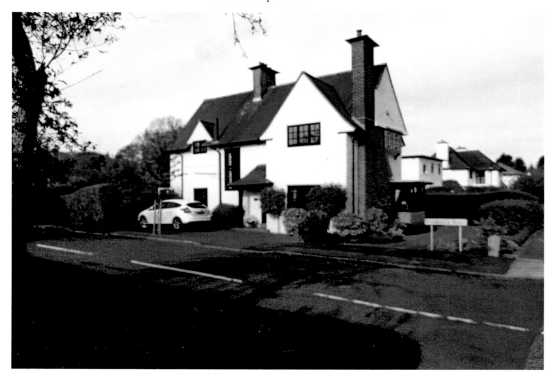

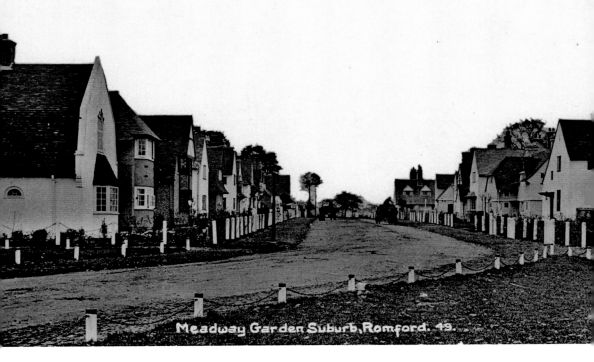

Meadway

A similar contrast between Meadway as first built and its more recent appearance.

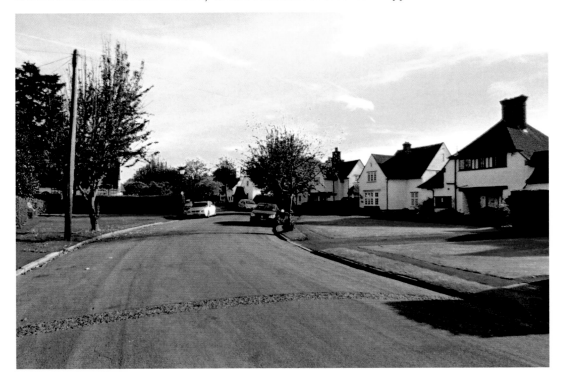

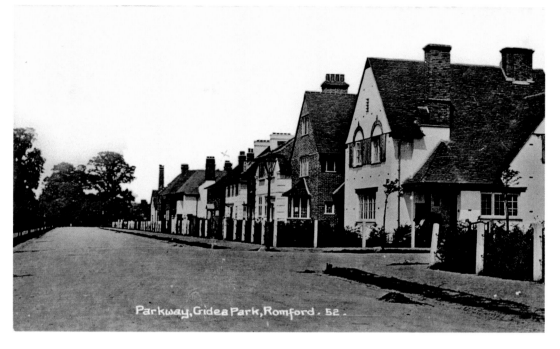

Parkway. Gidea Park. Romford. 52.

Parkway
Again the line of houses in Parkway shows that many bore white frontages in the early days. In the recent view small changes have not affected the general feel of the Arts and Crafts designs.

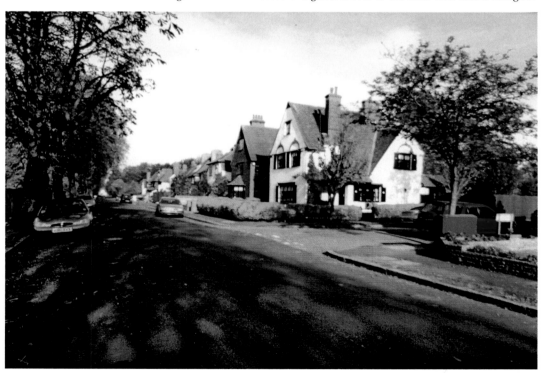

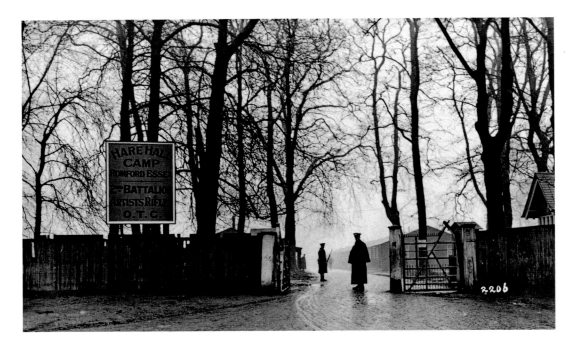

Hare Hall Camp Entrance

A wet day in 1916 sees sentries on guard at the Main Road entrance to the Artists Rifles 2nd Battalion OTC. Today this northern limit of the former Hare Hall Estate is occupied by the housing in Severn Avenue and adjoining roads, although some of the meadows remain as the playing fields of the Royal Liberty School, now installed in Hare Hall.

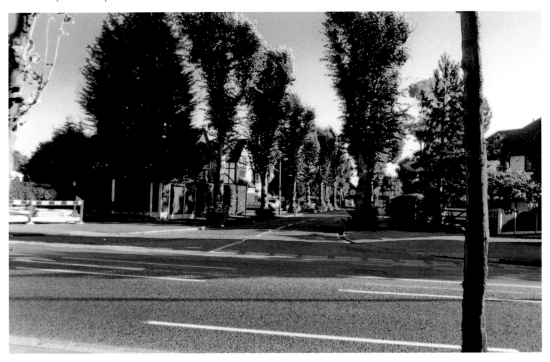

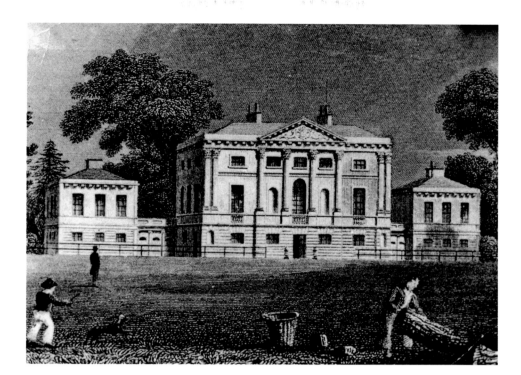

Hare Hall

A charming print of Hare Hall as designed by James Paine and built in 1768–69 by John A. Wallenger. It is described as 'A handsome mansion of Portland stone'. In 1848 it was said to have had part of a petrified tree brought from the Isle of Portland in its pleasure grounds. Since 1921 it has been part of Royal Liberty School, and a considerable bulk of later buildings now form a quadrangle behind the historic building, whose side pavilions have been joined to the central house. All of this is now visible across the remaining fields.

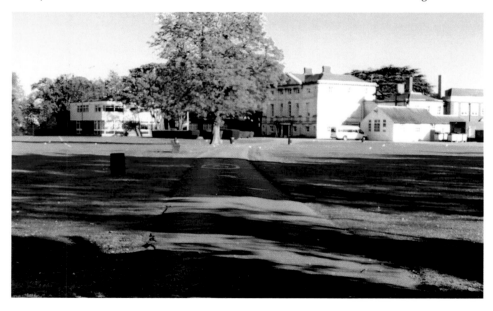

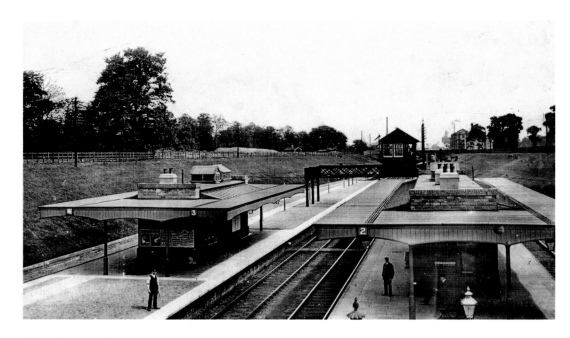

Gidea Park Station

Squirrels Heath and Gidea Park Station – as it was called when it was first opened to serve the Gidea Park Garden Suburb of 1911 – is shown complete with its original signal box and rural surroundings in a small cutting. In recent times the catenaries and wiring of the electrified lines frame the platforms and station buildings. The bare slopes as first built are now a verdant mass of trees.

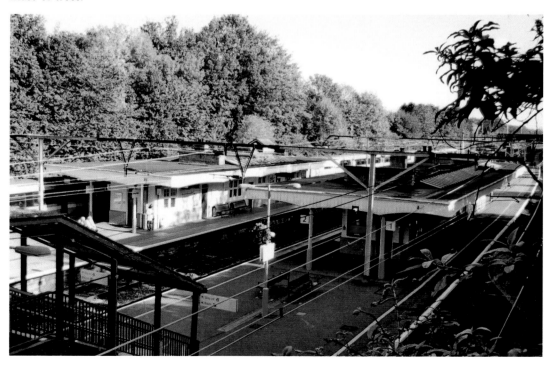

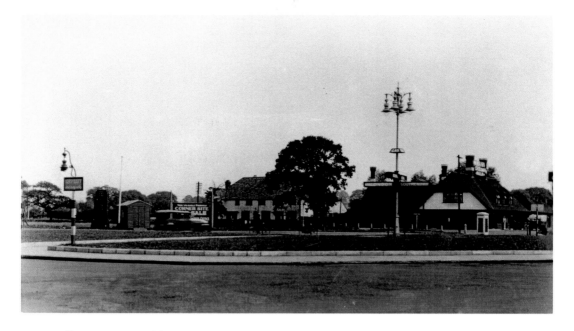

Gallows Corner, Wide View

This complicated junction created by the construction of Eastern Avenue and the Southend Road in the mid-1920s was overlooked by the police cottages at the bottom of Straight Road, centre left, and the Plough pub, seen in the background right. A current photograph shows the long flyover constructed by the beginning of the 1950s. The Plough, now closed and derelict, sits underneath. The growing traffic has led to the roundabout design being altered and adapted on many occasions since the 1920s, leading it to become much larger to take an increasing volume of vehicles.

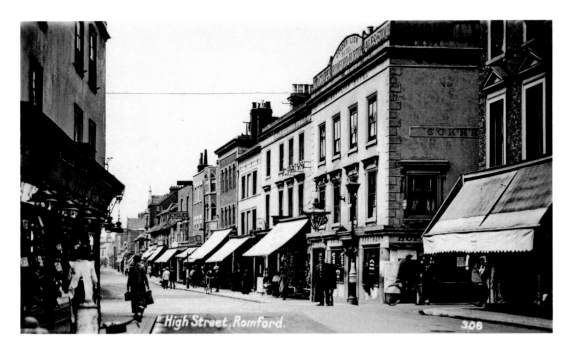

High Street, Romford. 306

The Centre of Romford

A different view of the Golden Lion and the High Street was once the norm. In the 1920s the western entrance to the market was narrowed by an extension of South Street and the large courthouse building is behind the cameraman on the left-hand side. Even the entrance to North Street on the right had to be widened and the scene changed again in the early 1930s when the courthouse and shop on South Street corner were demolished and the corner set back, leading to the more open prospect.

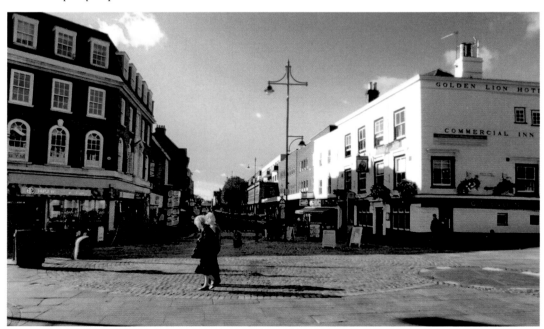

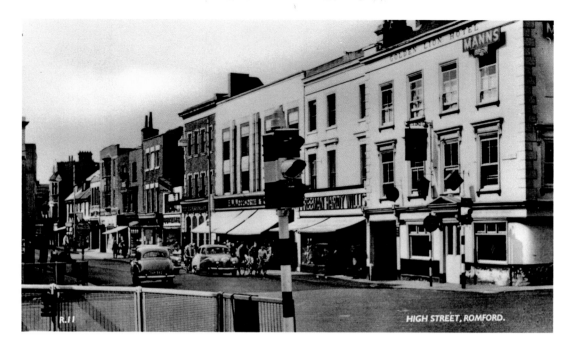

High Street East

In the 1960s and for a while later this was a familiar scene at the central crossroads of Romford. The ancient Golden Lion Inn on the far right had recently been threatened with demolition to widen the main road through Romford due to the increasing volume of vehicles using the route. Part of the High Street was in fact widened by demolition of old properties, but the traffic was relieved in the late 1960s by the construction of the Ring Road – St Edward's Way. Now the building next to the Golden Lion on the left, historically always a shoe shop, has become a restaurant, adding more outside seating to Romford's alfresco landscape which has developed over the few decades.

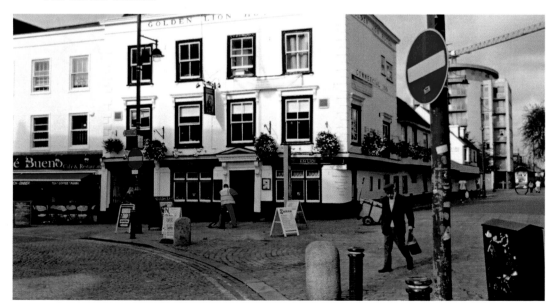

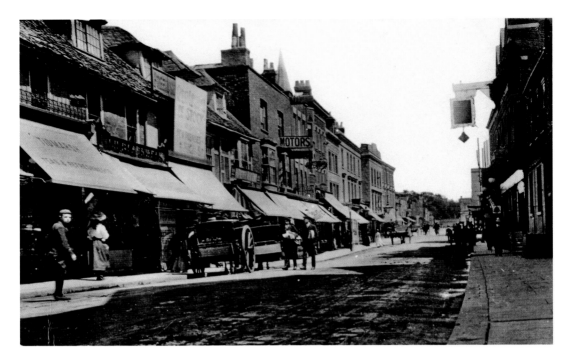

Old Buildings

A conglomeration of older properties on the north side of High Street is very evident in this Edwardian shot. On the right a prominent hanging pub sign looms above the White Hart Inn. The new arcaded shopping run on the left-hand side is often shielded by a queue of taxis awaiting custom on market days. Havering Museum has opened in the remaining Brewery offices on the right.

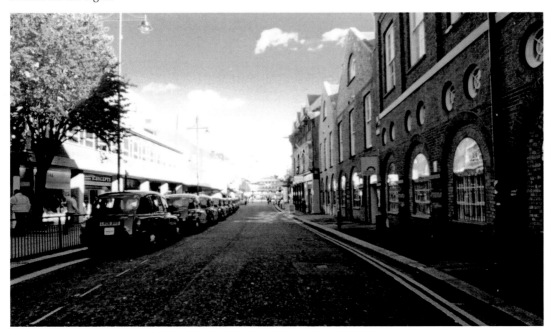

High Street Widening

In the foreground, the High Street looking towards the Woolpack from outside the Brewery still contains the un-widened part of the High Street with Sidney Grey's Radio Stores and the former butcher's shop. Beyond, the new arcaded section of shops with flats above has been completed. This is the summer of 1966. Trees now grace the pavement outside the arcades, with a public telephone box on the extreme right.

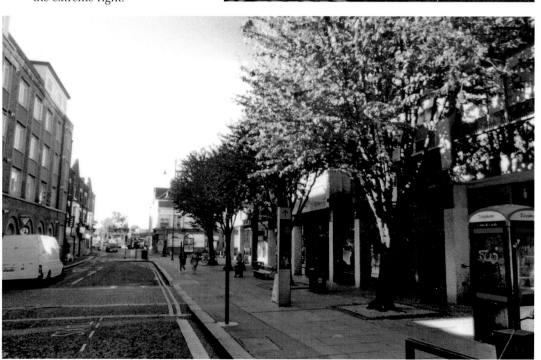

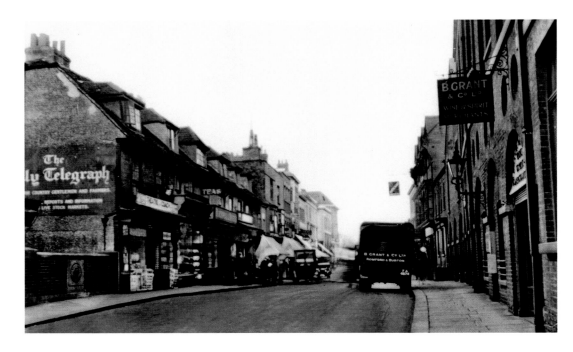

Fletcher's Booking Office

On the immediate left we see the bridge and parapet from which you had a view of the River Rom and old buildings upriver on the bend. Fletcher's theatre and coach-booking agency borders the bridge. Meadmore's Restaurant, where you brought your own alcohol to complement the excellent food as well remembered by many local people, is further along the block. A gentle rise in the ground shows where the Rom Bridge once was and a couple of restaurants in this area are complemented by a wedding shop and a betting shop, among others.

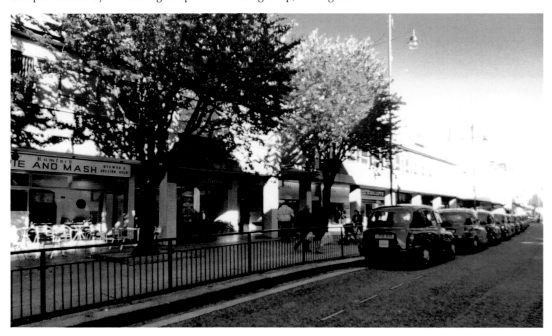

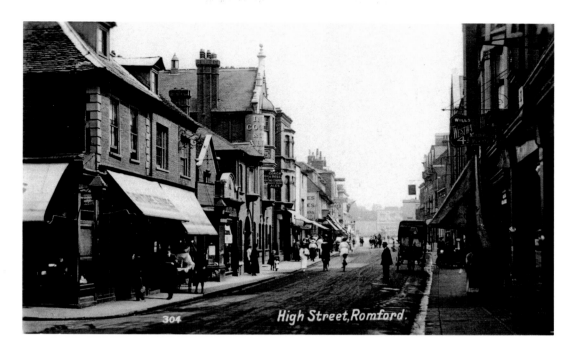

High Street, Romford.

Mawneys Crescent Corner

The jumbled but quaint nature of the north side of the High Street, with the Woolpack on the opposite corner, is very evident in this photograph taken during the First World War. The furniture shop extends round the corner into what was Mawney Crescent, with more shops at the bottom end of Mawney Road. The largest building is the famous Coach and Bell Inn, rebuilt in the late nineteenth century. The road on the left today leads to the multi-storey car park and the Crescent shops have gone. Direction signs are everywhere, and the High Street beyond is restricted to taxis and delivery vehicles.

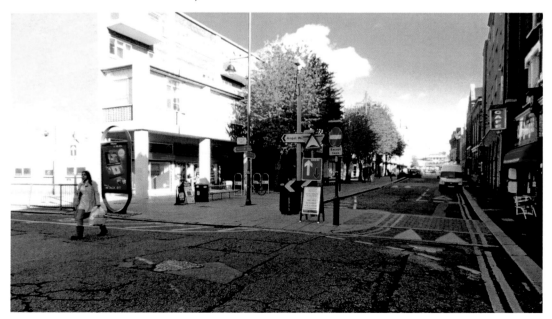

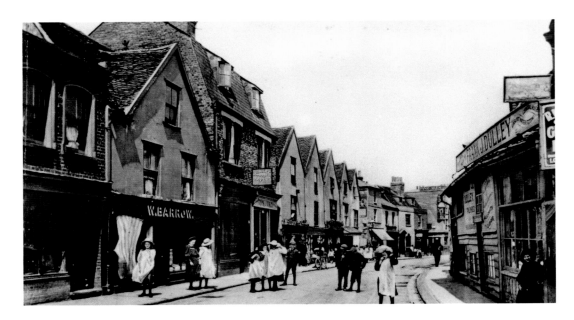

Western High Street

The considerable bend in this street was more noticeable in 1908 when the girls appear to be wearing their Sunday best. On the left-hand side there are some very ancient gabled buildings, with Frank J. Dulley's wooden-clad premises on the right and a very narrow pavement. The Salvation Army's Citadel on the left of the modern photograph has recently received a second makeover since it was built in the 1960s – General Booth would be very impressed if he could return.

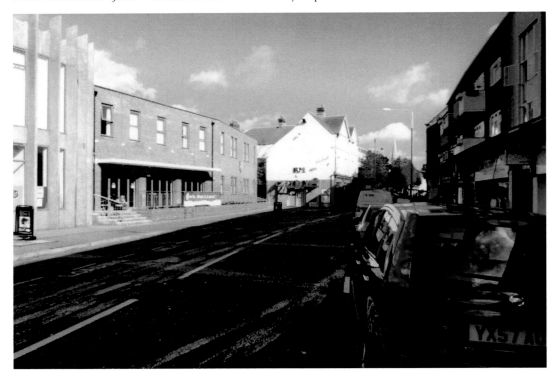

New Mill Inn

This lost pub at the beginning of London Road, in the mid-1960s might once have been the terminus of a projected tram route from Ilford, as the High Street beyond was too narrow in the early twentieth century, but in fact trams never reached even as far as this – Chadwell Heath being their outer terminus. This pub stood on the very corner of Waterloo Road. Today the site is near the centre of the London Road roundabout with the entrance to the Brewery shopping centre opposite.

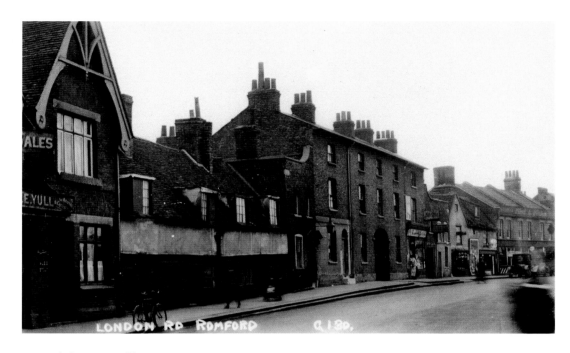

Beyond the New Mill

Edwardian London Road – the properties curve away in the opposite direction from the High Street and include some very ancient houses, Romford's early ribbon development on the road out of town. This area would have been well known to the soldiers housed beyond to the south in the Napoleonic barracks of the late eighteenth and early nineteenth century. Allen's dealership now houses their cars in the area occupied by many of these former buildings. This has opened up the view to the high-rise flats beyond, which replaced a nineteenth-century cottage estate after the Second World War.

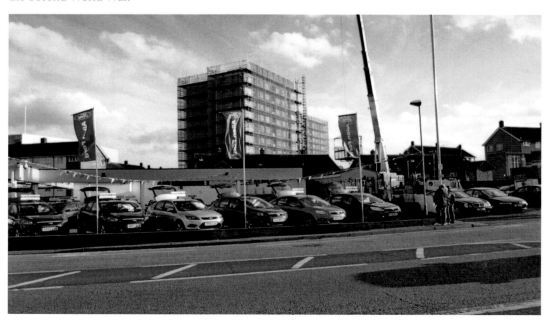

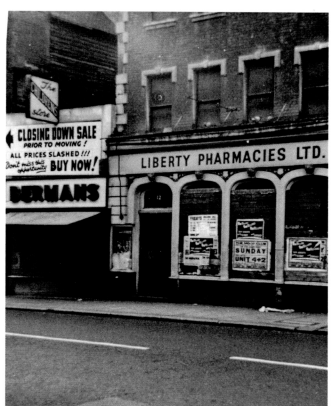

High Street Again

Liberty Pharmacies recently occupied this quaint shop, which had once been the London & County Bank. It is shown just before demolition in the summer of 1966, next to the ramshackle Berman's children's clothing store, which had finished its closing-down sale just before rebuilding and widening took place. Now the trees enliven the rather bland fascias of the arcade.

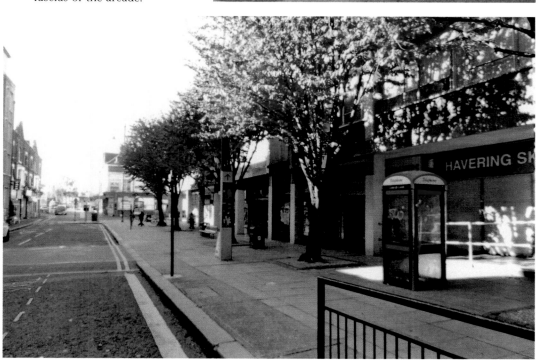

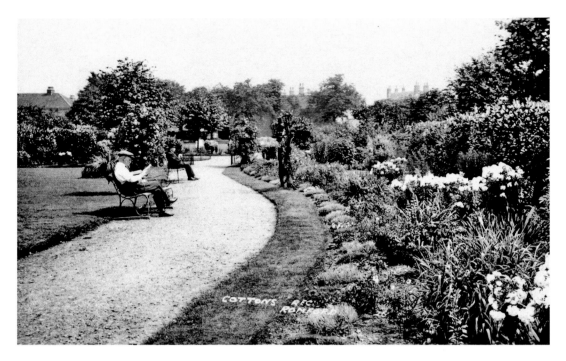

Cottons Recreation Ground

Retired people bask in the heat of the summer on the seats by the lovingly tended shrubberies in the 1930s. Cottons had been acquired by Romford Council in 1927 and in the above photograph had matured into a fine recreational asset for the town. Today a fringe of naturally wild plants sits at the edge of the pathway with a security wall behind.

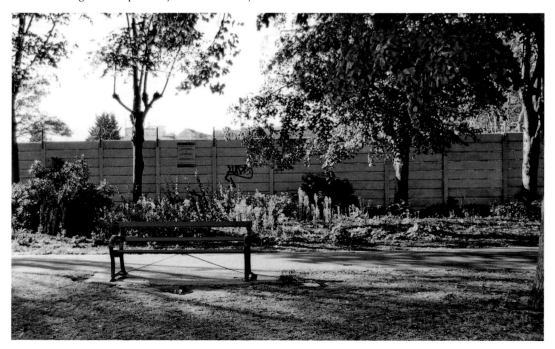

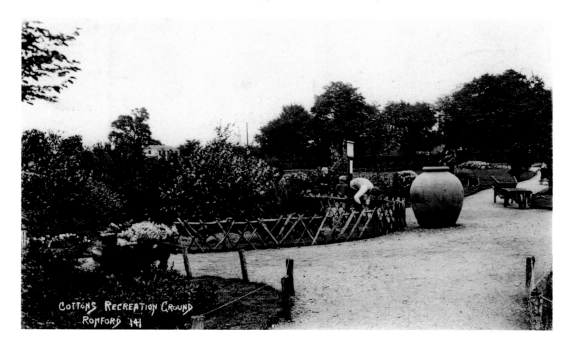

COTTONS RECREATION GROUND
ROMFORD 141

Men at Work

Soon after acquisition, much work had to be put into developing the former grounds of Cottons House into a municipal asset. Gardeners are at work inside a rustic fence, close to a giant planter and an ingeniously adapted wheelbarrow is visible at right centre in this view showing the early days of development. Today, a sculpture group commemorates six local people who were killed in the Second World War shelter in the park. The Friends of Cottons Park have been responsible for new initiatives in this area.

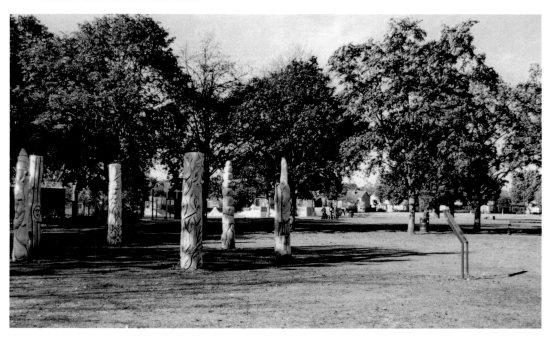

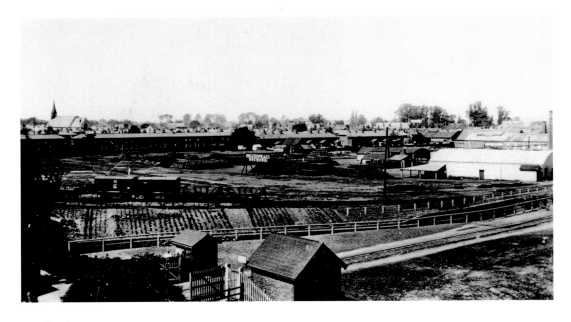

Romford Brewery

In the early decades of the twentieth century, the extensive premises of Ind Coope's brewery are laid out in front of the camera. We can see stacks of wooden barrels, the brewery railway that connected up with the main line, and at the rear the old cottages in Waterloo Road. Mid-century the old cottages housing many of the brewery employees were replaced by new council properties including high-rise elements. Operations at the brewery ceased in the early 1990s and a shopping centre eventually materialised on the site. Shoppers stroll through the walkways between the shops and car parks.

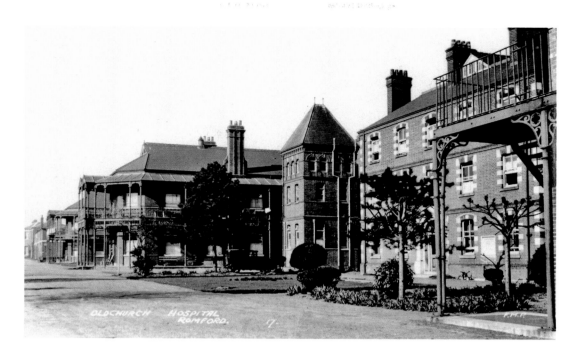

Hospitals

This general view of the Oldchurch Road site shows the original workhouse infirmary buildings around 1930. Two of the iron, galleried ward blocks of what had become a general hospital are in view, together with an administrative building at the centre. The new Queens Hospital has arisen on a site opposite on what was previously Oldchurch Park. It is well served by a bus station, part of which is shown in the foreground.

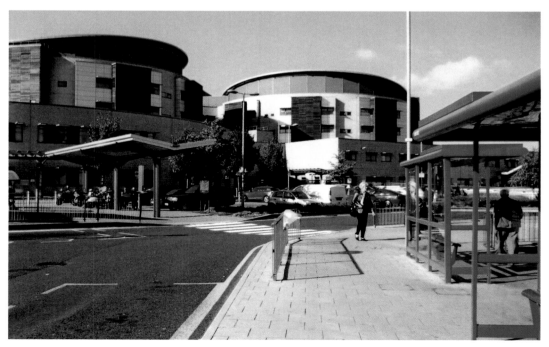

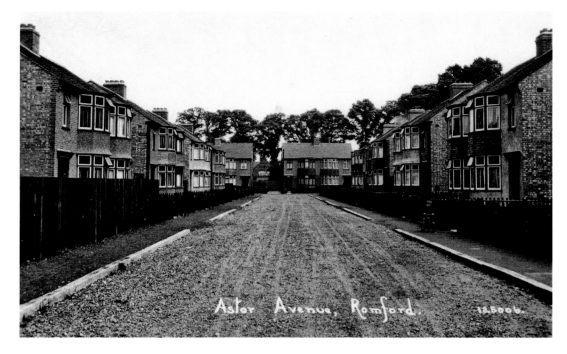

Astor Avenue

The older photograph of the avenue south-west of Crowlands School, off London Road, shows it as a quiet backwater in the 1930s. Quite surprisingly for a back street, this was made into a postcard view. Now the area is a little busier, mainly influenced by the ubiquity of the motor vehicle.

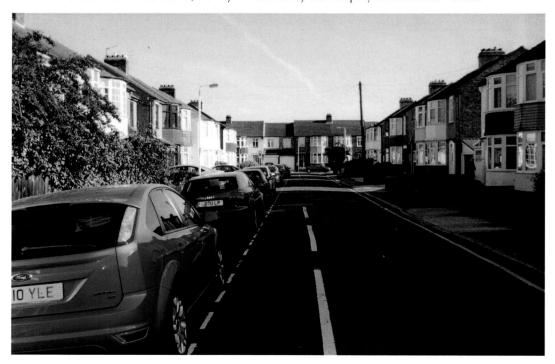

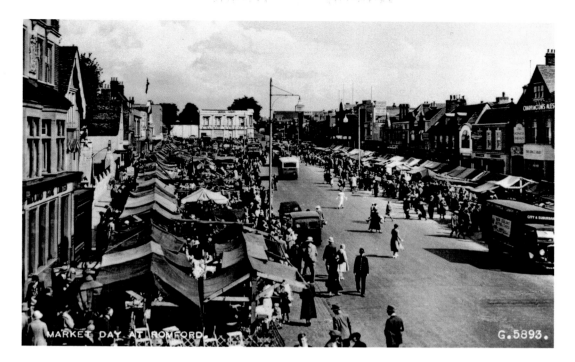

Romford Shopping

In the 1930s, shopping was mainly confined to the Market Place, as seen here on a general market day on High Street and South Street. In the late 1960s a movement began towards large areas of pedestrianised shopping. This modern view shows an exit from the Liberty Shopping Mall, which was at first an uncovered centre but has now been given an extensive glass roof. This was praised by the architect Maxwell Hutchinson on a flying visit for the BBC.

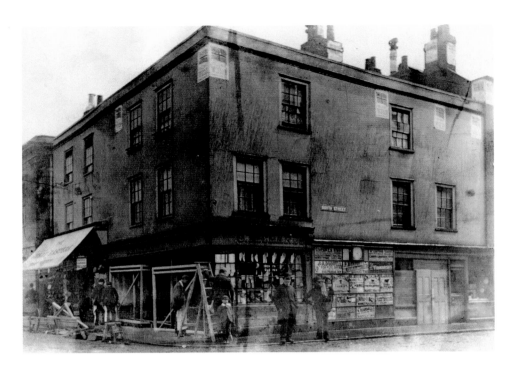

Traffic Improvement

At the corner of South Street and Market Place today, we see the opening that allows us a view along Market Place. The Co-operative Bank at the corner was built as the National Provincial Bank in the 1930s. The older picture shows the mass of buildings that was later demolished, as it was around 1906 when improvements were being made to the windows. The courthouse in the Market Place lay behind and disappeared at the same time.

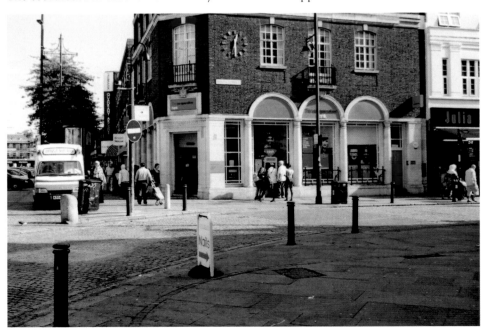

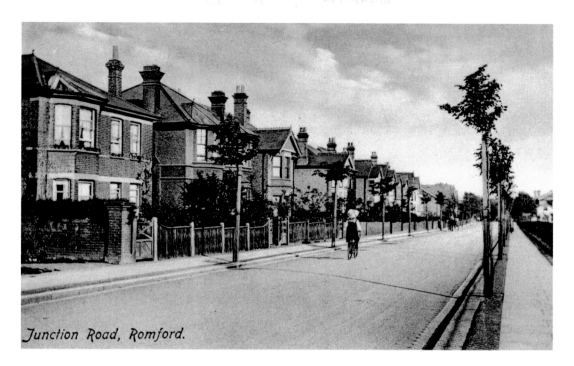

Junction Road, Romford.

Junction Road

The fully built-up eastern side of the road around 1910. This portion was built later than the southern half and Junction Road at this point was only a footpath. A number of the town's businessmen had houses here. The right-hand (western) side was not built on until later. Various alterations have been made to the buildings but they remain, proudly standing as an example of the workmanship of over a hundred years ago.

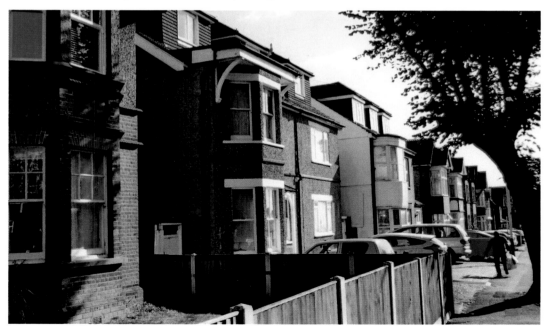

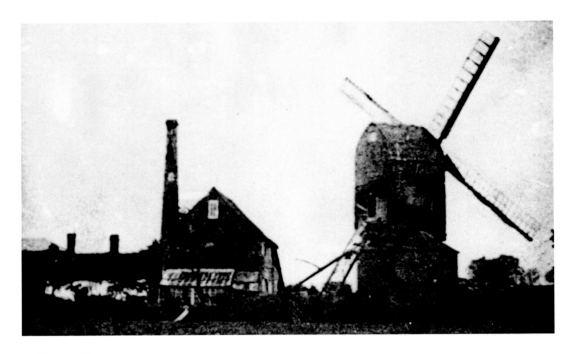

Collier's Mill

This Post Mill was located on Main Road and there were several outbuildings. The chimney appears to indicate that there may have been a steam mill here towards the end of its operation in the nineteenth century, after having stood here at least 100 years. This is the only known photograph but the mill is shown on Ordnance Survey maps with a pictogram. After the mill there was a mansion known as Hill House. Later in the 1930s these interesting Art Deco apartments were built on the site. Just a short step from the Market Place and other central facilities, this was and is a very convenient address.

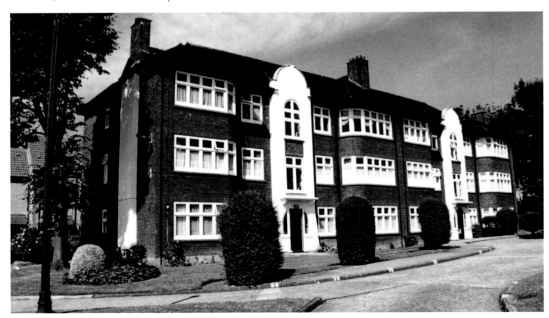

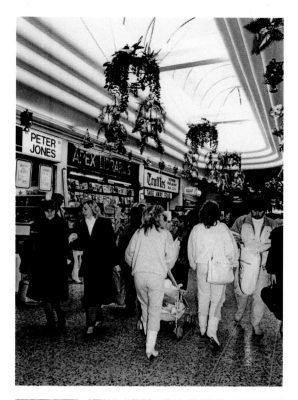

Interior of the Quadrant Arcade
Built in the mid-1930s to continue the
tradition of covered shopping areas
in the town, this had perhaps been
started by the 1930 Romford Arcade in
South Street followed by the Romford
shopping hall in the Market Place just
before. Quadrant Arcade uniquely links
two important shopping areas: South
Street and the Market Place. The modern
Stewards Walk provides another entry
into the Liberty precinct using the
former entrance into a cinema.

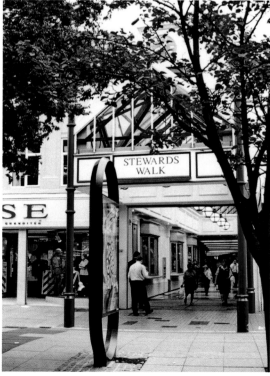

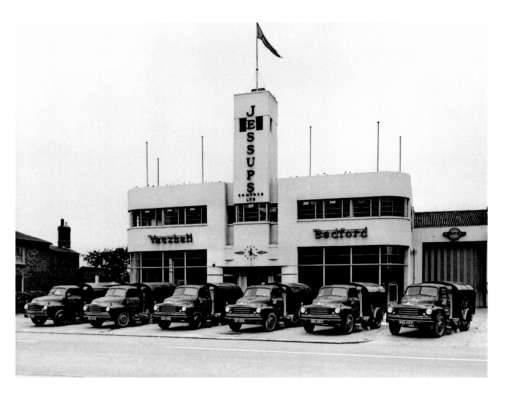

Jessups
This wonderful building of Art Deco appearance in London Road used to make people aware they were approaching Romford proper. Unfortunately, it has been swept away today by apartments and this utilitarian motor car dealership stands in its place.

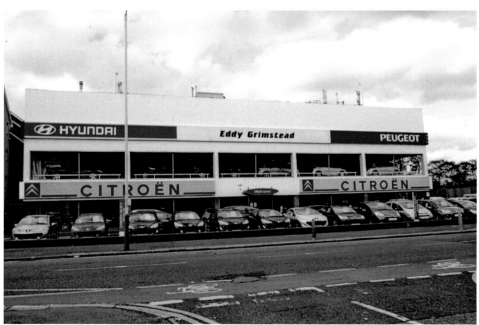

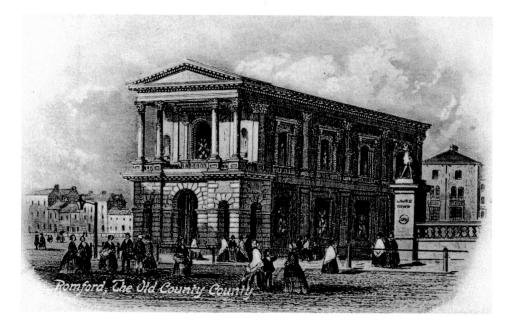

Romford, The Old County County

Laurie Hall

This mid-nineteenth-century structure was meant to give classical dignity to the end of the Market Place. Built on piles, it covered part of the old loam pond. Laurie Square and the Laurie Town development of semi-detached townhouses were shielded from the bustle of the Market Place in cattle market days. Tollgate House, meant to reflect the style of an older building, now encloses this end of the market, but various problems have ensured that it is covered in scaffolding a number of years after its original construction. The clock tower provides the time for all to see.

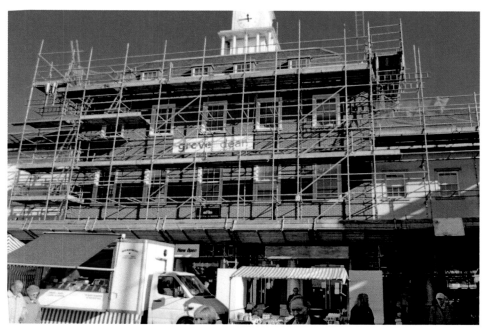

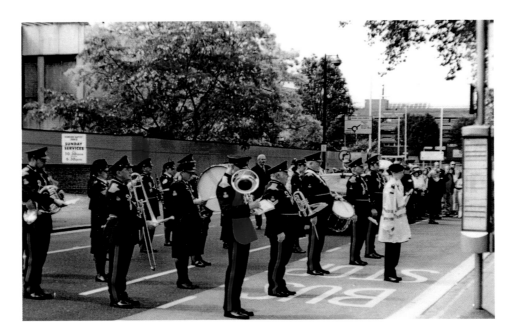

Heroes Honoured
The Salvation Army Band stands to attention outside Coronation Gardens to salute the memory of the fallen heroes from this locality, commemorated on the war memorial.

Acknowledgements

Peter Buchan.
Keith Langridge.
Brian Rider.
Ivan Sparkes.

Thanks to Christine Cole and John Sunley for a timely ride.